forgotten TALES of SOUTH CAROLINA

Sherman Carmichael

illustrations by
Kyle McQueen

Charleston **H** London
THE
History
PRESS

Published by The History Press
Charleston, SC 29403
www.historypress.net

Copyright © 2011 by Sherman Carmichael

All rights reserved

First published 2011
Second printing 2012

Manufactured in the United States

ISBN 978.1.60949.232.8

Library of Congress Cataloging-in-Publication Data

Carmichael, Sherman.
Forgotten tales of South Carolina / Sherman Carmichael.
p. cm.
ISBN 978-1-60949-232-8
1. South Carolina--History, Local--Anecdotes. 2. South Carolina--
Social life and customs--Anecdotes. 3. Tales--South Carolina. I. Title.
F269.6.C37 2011
975.7--dc22
2011000837

For everyone who believed in me

Acknowledgements

Without the following people, this book would never have been written: Beverly Carmichael, who for the many hours we traveled proofread and corrected my stories; and Rebecca Dunahoe, who provided the story about one of our ancestors and many words of encouragement. More words of encouragement came from Ric Carmichael, Lynette Goodwin and April Asaro.

Prologue

South Carolina is rich in history, and along with history come mysteries and legends. Whether these stories are true or just campfire tales, they still hold our attention. The stories in *Forgotten Tales of South Carolina* are based on research of reported actual happenings. All of these stories are based on stories from around the Palmetto State. I have tried to collect as much information relating to South Carolina as possible. Variations of some of the stories you are about to read have been handed down for hundreds of years and may bear some similarities to stories from other states.

Forgotten Tales of South Carolina

Ghost Lights

When the sun sets in South Carolina, many talk of the darker side. Some are skeptics and nonbelievers, while others are believers and will heed the warnings of folk tales, legends, myths and ghost stories handed down from generation to generation. Though time has erased many names, exact dates and exact locations, these stories still catch the interest of many people today. Are they campfire tales or true stories? Scientists and other skeptics have tried to disprove the very existence of ghosts and other unexplained phenomena since they began investigating them. None has yet been scientifically proven to exist or not to exist.

Strange lights have been seen throughout recorded history from the time of Columbus to the present day. This unexplained phenomenon, described as a glowing ball, or balls, or glowing orbs of light, has been recorded throughout the world. They seem to appear in every color of the rainbow. In some locations, they have been reported to emit more than one color, usually two. They have been reported to sparkle, be stationary or move. Some have been reported to be high in the air, while others are low to the ground. Normally, the lights will vanish or move away when one moves too close to them. No one has been able to approach them to get a good visual. They always seem to be observed from a distance.

You may have seen or heard of these lights in a location near you. There are many different names, depending on the location, the story and who's telling it. Some names given to the ghost lights are earth lights, St. Elmo's fire, fox fire, will-o'-the-wisp, spook lights, earthquake lights and ball lightning. Every location seems to have a different name for them.

In the United States, they generally appear in the southern and western parts of the country. This could be because these parts of the country are riddled with ghost stories. They are usually in a fixed location. They are comparatively reliable in appearance, location and time.

Many theories and legends surround these mysterious glowing lights. Some theories include ignited gas from marshlands or reflections from car lights or a nearby town. Some people have even gone so far as to say that the lights

come from farmhouses across the woods. None of these theories has held up to scientific study.

Some common folk tales are about ghostly Indian braves, UFOs, ghosts of slaves or ghosts of Confederate or Union soldiers. Others include the ghosts of condemned sinners left to wander the world for all eternity. In some locations, ghost lights are known as a death omen. Legend has it that anyone who sees these lights is sure to die soon.

Earth Lights

Earth lights are a rare light phenomenon often mistaken throughout history for dragons, UFOs and ball lightning. One leading scientific theory, still not proven, is that the lights are produced by tectonic strain in minor earthquake fault lines. However, they are seen in locations that do not have recorded fault lines.

They appear in many colors, with glowing orange seeming to be the most common. They come in a variety of sizes, from very small to basketball size.

The sightings appear at night or late in the evening after the sun has gone down, when they can be seen from long distances. They have also been reported to move against the wind.

Persinger and Lafrenière were the first scientists to recognize the ghost lights phenomenon in the late 1970s. In 1982, Devereux brought the phenomenon to wider public attention with his publication "Earth Lights."

Persinger introduced the phrase "anomalous luminous phenomena" to avoid the UFO controversy and all the negativity associated with it.

St. Elmo's Fire

St. Elmo's fire is an electrical discharge often observed around masts of sailing ships and poles that cause ionization of the surrounding atmosphere. It often produces crackling noises, as well as gives a luminous glow, and often disappears with a bang. St. Elmo's fire has been known to cause radio interference.

Both Christopher Columbus and Charles Darwin recorded in their writings that they observed this light phenomenon, which many times appears after a thunderstorm. This is believed to be a signal of clearer weather ahead and thus was a good omen to sailors.

St. Elmo's fire has been mentioned in the writings of Julius Caesar and Shakespeare.

Fox Fire

Fox fire is a naturally occurring phenomenon sometimes visible in the woods at night. Its source is a bioluminescent fungi growing in special conditions. It usually appears on rotting tree bark.

Fox fire is caused by many different species of fungi, although *Armillaria mellea* appears to be the most common.

Armillaria mellea emits a bluish green glow similar to children's glow-in-the-dark toys. There have been a few reports of a reddish glow, probably caused by another species of fungi.

The following fungi may cause bioluminescence: *Armillaria mellea, Collybia tuberosa, Mycenae chlorophos, Armillaria ostoyae, Mycena citricolor, Pleurotus nidfformis* (ghost fungus), *Omphalotus olearius* and *Mycena rorida* (luminous spores).

Will-o'-the-Wisp

The will-o'-the-wisp has been recorded as flickering over marshy ground since the Middle Ages. Sir Isaac Newton mentioned the phenomenon in his 1704 *Opticks*.

The most commonly referenced explanation for the will-o'-the-wisp is ignited marsh gas. Most likely, this marsh gas is slowly leaking methane whose ignition can be triggered by phosphene, also called phosphorus hydride.

Contemporary accounts of the lights defy that theory, given the fact that in some reports the lights are seen to move and not give off any heat.

Other names given to these lights are treasure lights, corpse candles, fairy lights or a lantern carried by a spirit.

Bingham Lights

Located in a small community near Dillon, South Carolina, down a dirt road and off the beaten path, are the Bingham

lights. There are several suspected origins of these mysterious lights. Exit I-95 at Dillon, and at the historical marker you will see a dirt road that leads back into the woods. While all accounts are centered on the railroad tracks, the tracks have long been removed.

One version of the legend of the Bingham lights is that a train hit John Bingham in the late 1800s or early 1900s, depending on who is telling the story. He was flagging down the train with his lantern and was struck and killed. The lantern is the light that you see. John Bingham is still waving his lantern. There is no account of why Bingham was waving the lantern at the train. Some say that if you walk a mile or so down the dirt road and start yelling for him, the light will appear. They say that you will know that you're close because the temperature will drop.

Another version says that to summon the lights, you just yell for John (or possibly Bill) Bingham. This version also reports that the temperature will drop rapidly before the light appears. One person reports that he shot at the light with a .30-06 rifle; the light split and changed colors. It is also reported that it will change colors if you shout at it.

Another legend says that a black man named Bill Bingham was walking down the tracks near the woods of Reedy Creek Springs. Several different theories are handed down about why he was walking near the tracks. One claims that he was a murderer and this is where he hid the bodies. Another says that he was walking home this way because it was a shortcut. He always carried a lantern

when he walked. He was walking too close to the tracks, and a train hit and killed him. Some say his head was cut off when the train hit him and that he's still looking for his head today. Others say he's just trying to get home.

The most popular version is that a local farmer was hunting one night. He was walking down beside the railroad tracks when he noticed that part of the track was still under construction. He heard the train coming and stopped to try to fix the track before the train got there. He was unable to fix the track as the train drew nearer. He took his lantern and started waving it in the air in an attempt to signal the train, but the flame was growing smaller. While trying to signal the train, he tripped and fell on the track, and the train ran over his head.

The different sizes of the flame in his lantern could account for the changing colors of the light.

Land's End Light

St. Helena Island near Beaufort, South Carolina, hosts South Carolina's most famous ghost light: the mysterious Land's End light on Land's End Road.

There are several stories of the Land's End light. No one knows which is true. All have been handed down through generations.

The best place to see the light is between Adams St. Baptist Church and the Old Hanging Tree. Legend has it that some runaway slaves were caught and hanged from

that tree. When you come to a small community called Frogmore, watch for the sign to Land's End Road. Turn on Land's End Road and go to the Chapel of Ease.

The church was built between 1742 and 1747 to serve the planters on St. Helena Island. In 1886, a forest fire destroyed parts of the chapel, but the ruins and the graveyard still exist.

Some reports state that the light resembles a ball of fire, or a large white ball of fire with a reddish halo. Others report a reddish glow, while some report mercury blue. It seems that no one can agree on the description of the Land's End light.

There are many ghostly tales from the Civil War, and the Land's End light is no exception. Some believe it's the ghost light of a Confederate soldier who was ambushed and decapitated by a Union soldier. The Union soldier then tossed his victim's head into Port Royal Sound. The body was left near the road. It is said that to this day the Confederate soldier continues to hunt for his head.

Another story that centers on the year 1948 tells of a busload of migrant workers headed home after dark. There was a fight on the bus, and the driver was distracted. The driver ran the bus into a live oak tree, killing himself and a number of the migrant workers. The exact number of workers to die in the crash is not recorded.

Some years ago, a group of marines from Paris Island decided to check out the light on their off-duty time. When they spotted the light, the marine driving their car decided to

drive into the light. He drove through the light and crashed the car into a tree head-on. He was killed in the accident.

Some people believe that residents of the area buried their family treasure during the Civil War to keep the

Union soldiers from getting it. They believe that the ghost light is linked to the buried treasure.

Another story tells of a Federal soldier who was beheaded in a skirmish. Another says that an unhappy slave was sold to another owner and was forced to leave his wife on the island.

Many people, including law enforcement officers, have reported seeing the Land's End light. It sometimes rises up in the air like a bouncing ball of fire. Some have reported that it will disappear when someone approaches it.

The light has also been reported wandering around the remains of Fort Fremont. Fort Fremont is located on the southwest tip of St. Helena Island, and it protected the Port Royal Naval Station. In 1906, the Port Royal Naval Station became the Paris Island recruiting and training depot for the United States Marine Corps.

Summerville Lights

Again, there are different stories about these mysterious lights. Some stories resemble those of other ghost lights in South Carolina.

In Summerville, South Carolina, there is a well-known ghost that roams the area known as the Light Road. The ghost roams with his or her light almost every night.

In the 1800s, there were railroad tracks there instead of the dirt road. Every night, a man would wait by the railroad tracks for the train. No reason was ever given to explain why

he waited on the train. One night, the train was running late. The man laid his head on the tracks to listen for the train. Somehow, the train ran over his head. It's still a mystery why the man didn't move his head before the train ran over him.

The railroad tracks are now long gone and have been replaced by a dirt road. The ghost of this man still walks the road every night looking for his head. It appears that he's swinging his lantern as he walks. His lantern is the only light you can see no matter how close you get.

One night, a group of friends decided to go down the road to see if the light was real or just an old campfire tale. About midnight, they were driving down the road when one of them looked back and yelled, "It's behind us!" They stopped their truck and looked behind them, and there was the light about thirty feet back. Frightened, the friends decided to leave. On the way out, the light appeared in front of them. The light soon disappeared, and they left.

Another story tells of a woman whose husband worked for the Summerville Railroad Company. He was the night conductor on the late-night run. Every night about midnight she would be waiting by the tracks with food for her husband. She always carried a lantern so she could see her way and so he could see where she was. One night, her husband never arrived.

She was later told that the train had derailed and her husband had been killed. It was rumored that he was beheaded in the accident. The grief-stricken widow never accepted the fact that her husband was dead. She continued

going to the tracks at midnight carrying her lantern. She would walk up and down the tracks, waiting for him to come.

The area residents began to think that the tragic death of her husband had driven her crazy. She continued her nightly pilgrimage until her death. After her death, it was said that she continued to walk the railroad tracks waiting for her husband. Mysteriously, the lights have never stopped appearing.

Many have said that if you go to the tracks a few minutes before midnight, you can hear all of the normal nightly sounds. At midnight, all sounds cease. It becomes deathly quiet. Then you can see the light.

Another version of the story is set in the late 1800s. A local man worked on the railroad. Every night, his wife would leave a lantern on so he could find his way home. One night, her husband didn't arrive home as he had done for many years. Worried about him, she took the lantern and went out in search of him. She didn't find her husband.

She later found out that her husband had been involved in a train accident, and his head had been severed from his body. His head could not be found, so they had to bury his body without it.

His wife, unhappy with her beloved husband having to be buried without his head, would go out searching for his head. She continued to search diligently for her husband's head until her death. Some believe she still haunts the tracks to this day.

Several friends decided to go down this road (originally named Sheep Island Road) one Halloween night. As they turned onto the road, which is part of Light Road, their

car—a new car—stalled. After several attempts, they finally got the car started. The driver looked into the rear-view mirror and saw a light. The light was rapidly approaching the car. At first, they thought it was another car. Then the light disappeared. They left without seeing the light again.

Lights of Ravenel

A sad and tragic accident occurred one night when a log truck ran over three teenage boys on a dirt road about twenty miles south of Charleston.

The community mourned the loss of these three teenage boys. The funeral services were held in the Baptist church on the same road where they were tragically struck down. The boys were laid to rest in the graveyard behind the church.

The story goes that if you knock on the church door three times and say, "I want to see the lights" three times, the lights will appear on the road where the teenagers were killed.

The lights first appear as a single white light at a distance. Then, as they move closer, the single light separates into three white lights lined up side by side. They always vanish before anyone can get close to them.

Another story claims that the lights start out as a single red light that moves toward you, then moves away from you and suddenly disappears. If you go back a second time, the lights will appear white, and the three lights will be on top of each other like a traffic light. The lights will disappear if you approach them.

UFOs and Flying Saucers

On June 24, 1947, Kenneth Arnold reported that he had seen nine saucer-shaped aircraft flying near Mount Rainier, Washington. Since then, UFOs or flying saucers have been seen in every state in the United States and in every part of the world.

UFOs are one of the most controversial subjects around today. Many people who witness a UFO are afraid to report it, afraid of being classified as a candidate for the funny farm; others take the risk and report it, only to be told there's no such thing as a UFO. Some are ridiculed, some threatened and some have lost their jobs for reporting a UFO. Many reports are nothing more than hoaxes, while others are explainable as stars, aircraft or some natural occurrence. It's those few that cannot be explained that continue to baffle people.

South Carolina is no different than any other state. It has had its share of UFO sightings. To some, it has become a hotbed of UFO activity.

Gaffney UFO

Just before dark on Sunday evening, February 22, 2004, at approximately 6:15 p.m., a couple was driving south on Corinth Road near Gaffney, South Carolina. The sky was clear, resulting in excellent visibility.

The couple noticed a bright, white, luminous object flying slowly toward the road. It was on the east side of

Corinth Road, traveling from the northeast toward the southwest. They estimated it to be about fifty feet high.

The object appeared to be about four to five feet in diameter and spherical in shape. The outline of the flying object seemed to have an indistinct edge. The witnesses described it as a fuzzy, white, translucent ball of light with a group of red rods coming from the bottom. The rods appeared to be tightly grouped in a circle and slightly toward the rear. They were emitting gold-colored sparks.

The object drifted over their car and the roadside power lines, barely missing the power lines by about ten feet. They could not hear any sound from the flying object as it moved silently through the air.

As the flying object moved farther away from their car, they could see what seemed like the images of clouds through the object, as though it were transparent.

The object was now moving west toward the trees. It was losing altitude. It flew into the tops of some small trees and stopped approximately three hundred feet from Corinth Road.

The witnesses reported that the gold-colored sparks continued to fall from the object. The treetops around the object seem to catch fire. The trees had shed their leaves but had a lot of vines wrapped around their limbs. The flames were described as gold colored, moving kind of like electricity. The gold fire or electricity seemed to start around the tree trunk and move out in all directions for several minutes until the treetops and limbs were shimmering with gold-colored light.

After several minutes, the leaves on the ground started to flare up in a bright orange glow, even though they were damp from a recent rain.

The witnesses pulled into a driveway and called 911. A family came out of their house in time to see the ground fire beginning and attempted to put out the fire with their feet.

The firefighters from the Corinth Volunteer Fire Department arrived on the scene minutes after the 911 call came in. They extinguished the ground fire with their fire extinguishers. No water from the tanker trucks was needed. By the time the fire was extinguished, it was nearing dark.

At this time, the object could no longer be seen in the treetops. No one on the ground saw the object leave.

When the firemen got the fire extinguished, witnesses told the firefighters that the fire had been started by an object that came out of the sky and landed in the tops of the trees.

The fire chief took his flashlight and looked up in the trees in the burnt area. In the top of one of the trees, about twenty feet high, was a piece of what appeared to be silver-colored, possibly metallic, material. It was rectangular in shape, about six inches by twelve inches, and looked something like wrinkled aluminum foil.

The fire chief thought it might have been an aircraft. The fire chief had his communications center contact the Federal Aviation Administration (FAA). He was told that no aircraft had reported any trouble and that there were no aircraft in that area. The FAA communications person

advised him not to touch metallic material; he would have someone check it out in the morning.

The fire chief and one of his firefighters returned to the scene the following morning to get a good look at the metallic object in the daylight. The metallic object was no longer in the treetop. The firefighters did a sweep of the area and turned up no evidence of any metallic material.

The burned area was about twenty-one feet by twenty-nine feet. The fire did not spread beyond the area affected by the source of the fire. There were no signs of burning in the treetops.

Gaffney has a long history of UFO sightings, going as far back as the 1960s. There were many UFO sightings in the '60s, '70s and '80s.

There were cases where the occupants of the UFOs were seen. On one occasion, two police officers saw a dark spherical object with a flat rim land. A small man in a shiny gold suit got out of it.

On February 27, 1973, a police officer saw a UFO hovering over the city's reservoir.

The significant number of Gaffney UFO sightings brings up the question: why would a small South Carolina town attract so many UFOs?

Beaufort UFO

Beaufort, South Carolina, is located near a marine and naval air base. There were three witnesses to a UFO

sighting on September 9, 1991, at 9:00 p.m. The sighting lasted about five minutes. The sky was clear.

First report: Two witnesses reported a blue-white sphere with a luminescent humanoid floating inside.

Second report: Three witnesses reported that they saw a sphere with a humanoid for about five minutes. The humanoid appeared to be trying to communicate telepathically with one of the witnesses. The humanoid had a head shaped like the ace of spades. The rest of the body was humanlike.

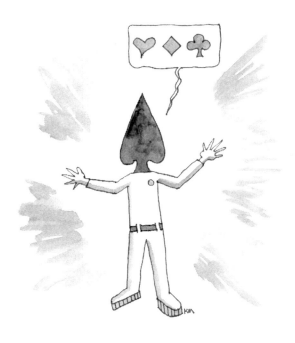

Clarks Hill UFO

On February 25, 2007, at about 11:00 p.m., there were three witnesses to a UFO sighting. The sighting lasted about an hour. The skies were clear.

One witness was stargazing and observed a group of colored lights in a V formation. The bottom of the V pointed toward the ground. The witness reported that after seeing the lights, a large green flash came from the right side of the lights and fell to the ground. A few minutes later, a red flash occurred on the right side of the lights and fell to the ground. There were no reports of anything hitting the ground.

Mount Pleasant UFO

On March 17, 2004, about midnight, there was a cloud ceiling at about ten thousand feet. Three amber objects in a V formation moved from the southwest. At times, one would disappear behind the clouds. They moved to the northeast and were visible for about six seconds.

Kingsburg UFO

Kingsburg is just a crossroads about four miles north of Johnsonville, South Carolina, where Highways 41-51 and 378 and the Old River Road meet.

On May 5, 2007, at 4:10 a.m., a witness reported that he was traveling down the Old River Road from Florence

headed toward Kingsburg. He observed a strange movement of lights that didn't look like an airplane. As he approached Kingsburg, it was hovering low in the sky to the left. The witness could not make out the shape of the object. It had a red blinking light on one side and a nonblinking white light. The object remained motionless, as if hanging on a string. The traffic light turned green, and the witness left.

Andrews UFO

On September 6, 2007, at 8:30 p.m., two witnesses were sitting outside under clear skies. One noticed four bright white lights in the sky over toward the highway. The lights seemed to be pointing down. The lights began to get dim and then faded out. Shortly after the lights vanished, the witnesses noticed twelve twinkling lights. They were moving in a northerly direction. At approximately 9:45 p.m., the witnesses noticed six twinkling lights coming back from the direction that the twelve lights had traveled. The six lights divided and vanished.

PHANTOM HITCHHIKERS

Phantom hitchhikers are some of the most popular ghosts worldwide. Allegedly, these restless ghosts are from victims of car or road accidents. These restless phantoms have not

gone on to the beyond and, for whatever reason, haunt the very spot where they met their deaths. Phantom hitchhikers have been reported for over a century, but it seems that in the last fifty or sixty years the reports have increased. The typical story usually tells of a lonely driver on a lonely stretch of road who picks up a hitchhiker and takes him or her to an address or location that the hitchhiker provides. The phantom hitchhiker then vanishes just before the car

reaches the destination or just after the hitchhiker exits the car. Many times, the hitchhiker will vanish in plain sight of the driver. On rainy nights, the car seat where the hitchhiker sat will still be wet after the hitchhiker vanishes. This typically happens on the anniversary of the tragedy. The driver, when relating his or her experience to others, is often surprised to find out that the hitchhiker has been dead for some time.

Phantom Hitchhiker of Walhalla

It is believed that the phantom hitchhiker on South Carolina Highway 107 is pilot Larry Stevens. Stevens was an avid adventurer and sightseer but a solitary person. His favorite pastime was flying his plane. He preferred solo flying. He kept a small, bright yellow with black trim plane at the Greenville-Spartanburg airport. When he flew, he always wore a dark-colored all-weather jacket.

He would have approached his last flight no differently than the hundreds of others he had taken. On that fateful spring afternoon, Stevens did the preflight check on his aircraft as he had always done. All systems were in order. Stevens boarded the plane for what he thought would be just another routine flight.

As he taxied down the runway and the wheels slowly lifted from the ground, it was another picture-perfect takeoff. As the airport faded into the background, he headed the plane toward the mountains.

Light began to fade, and Stevens found himself in the last golden glow of daylight. The sun was sinking low as Stevens continued to fly toward the mountains.

The sky over the mountains began to turn a menacing gray. The wind began to pick up, but it was not strong enough to force Stevens to return to the airport; he had flown in this type of weather many times. He could see clouds forming above the mountains. Hail (some reports say rain) began to hit his windshield. Before Stevens knew it, there was a downpour. The weather had closed in on him.

All Stevens could do now was continue to fly. He looked for a place to land his plane safely. He knew that in this kind of weather his fuel would not get him back to the airport. Seeing a small black ribbon below, he recognized it as South Carolina Highway 107. He hoped to use his remaining fuel to land safely on the highway. Before he could change course and land, however, his engine gave out. He crashed his plane into the side of the mountains in Oconee County.

The following morning, a plane flying over that area saw something yellow on the side of the mountain. The pilot swung around for a second look and realized he had discovered what looked like a plane that had crashed into the side of the mountain. He notified air traffic control, which in turn notified the proper authorities.

When rescuers finally reached the crash site, they found an aircraft with such severe damage that it seemed impossible that anyone had survived the crash. The search

and rescue team combed surrounding woods for hours, but no body was ever found.

Shortly after the recovery of Stevens's plane, people began to tell weird tales about a two-mile stretch of road on South Carolina Highway 107. A man began to show up just after dark on stormy nights between the Piedmont Scenic Overlook and Moody Springs.

One evening, a man was headed home along this road. It began to rain, so the driver was concentrating more on the mountain road than usual. It grew darker as the rain increased. As he rounded the curve near the Piedmont Overlook, his car lights hit what appeared to be the dark shadow of a man near the overlook. The driver pulled over and offered the man a ride. The man, wet and covered with mud, got into the car. He told the driver that he had to get out at Moody Springs. He never spoke another word. Upon reaching Moody Springs, the driver pulled over and the passenger got out. The man didn't thank the driver or acknowledge him in any way; he just walked a few feet from the car and seemed to vanish in a swirl of vapor in the night rain.

The next morning, the driver, returning to his car, found the seat wet and muddy, and there was a puddle of water on the floor.

Another traveler picked up the phantom hitchhiker at Moody Springs, and the hitchhiker insisted on getting off at the Piedmont Scenic Overlook. Both locations are along South Carolina Highway 107.

It's always the same story. A hitchhiker wearing a dark-colored all-weather jacket, muddy and wet, is picked up either going to Moody Springs or to the Piedmont Scenic Overlook. If he's picked up at Moody Springs, he gets off at the overlook. If he's picked up at the overlook, he gets off at Moody Springs. Each time, he just disappears as he walks away from the car. He has no conversation with the driver, except to tell him where he wants to get off. No one knew Stevens's exact age. It is believed that he was in his thirties in the 1950s. No traces of Larry Stevens's body have ever been found.

The Phantom Lady Hitchhiker

On U.S. 76 at the entrance of the Congaree River Bridge, an old ghostly hitchhiker appears, usually on rainy or foggy nights. The lady, appearing to be in distress, is usually given a ride. She gets into the backseat and tells the driver that she is headed to Columbia to see her mother. She gives the driver an address on Pickens Street. The apparition seems very lifelike and continues to talk with the driver. By the time the car is across the river, the lady has become silent. The driver looks back to see if the lady is OK and finds that she has vanished. Legend has it that in the 1940s, a lady was killed in the spot that is now the beginning of the bridge while trying to get to Columbia to see her mother. There is no record of how the lady was killed.

The Kingsburg Phantom Hitchhiker

No names or date are give with this story. The location of this story is Kingsburg, nothing more than a crossroads. Several abandoned buildings still stand there in disrepair.

Kingsburg is where Highways 378 and 41-51 and the Old River Road meet. A lot of traffic to Myrtle Beach and Florence travel this road.

The story goes something like this. A man keeps hitchhiking near Kingsburg. When a passing motorist gives the hitchhiker a ride, the man will talk with the driver or passengers. When they arrive at the first stop sign, the hitchhiker will vanish.

Wateree Bridge Phantom

On U.S. 378 between Sumter and Columbia, near the Wateree River Bridge, a young woman is trying to get to Columbia to see her ill mother. She appears very lifelike and talks briefly with any driver who picks her up. She disappears as the driver crosses over the bridge. She has been reported since the 1930s.

Swamp Girl

In a swampy area along Highway 378 between Sumter and Columbia, a phantom girl makes her appearance. She is well dressed in a long black dress and black hat and carries

a black bag. She is seen walking down a dark highway in the middle of thick swampland. When people stop to see if she is in need of help, she will accept a ride to Columbia. The upset and tired young lady relates to the driver that her mother, who lives on Pickens Street, is very sick and may not live. She tells the driver how hard she has been trying to get to her mother before her mother dies.

Over the years, many people have come to her rescue, only to find that she vanishes en route or just as they arrive at the Pickens Street address. When a driver can summon up enough courage to go to the house and inquire about the young lady in black, he or she is told that the girl was the sister of a past homeowner. She was killed in a car wreck while the Wateree River Bridge was being built, on her way to visit her sick mother. The girl in black appears on the anniversary of the date she lost her life.

The Lady in Blue

Caroline was sixteen years old with big blue eyes, an angelic face and long, flowing golden hair. Her mother had passed away during childbirth. She lived alone with her father on the Hilton Head Lighthouse island. Her father was the only employee of the lighthouse. He had to keep the lighthouse at its most efficient operating level. His days were spent making sure the wicks were cleaned and trimmed to the necessary requirements and that the lantern room's windows were always clean.

Every evening was spent carrying buckets of lamp oil from the storage shed up the stairs to the lantern room to keep the light burning bright all night. One night in 1898, Caroline's father was going to check the light, as he had done every night before. Suddenly, a storm hit the lighthouse island. Within minutes, the storm turned into a hurricane. The heavy rain and wind lashed out at the island and the lighthouse. Rumbling thunder and bright streaks of lightning accompanied the storm. The lightning lit up the sky as if it were daylight, and thunder shook the buildings on the island. High waves were pounding the island shore. One of the windows in the lantern room was blown out by the strong winds. Caroline's father covered the broken window the best he could. He continuously ran up and down the stairs, relighting the wick and bringing more fuel. Finally, he was out of breath, and severe pains filled his chest. He could go no longer. He slumped down on the stairs and breathed his last.

The young Caroline, awakened by the storm and frightened by the absence of her father, slipped on a dress and coat and hurried to the lighthouse to check on him. She found her father slumped over the stairs, not moving. Despite her crying and shaking, he didn't respond.

The storm hit the island hard for several days. It wasn't until days after the storm had subsided that anyone came to the island to check on the father and daughter. No sign of the father or daughter was found in the house. The search continued to the lighthouse. When they entered

the lighthouse, they found a tragic sight. Both father and daughter were dead.

It was determined that the father had died of a heart attack. It was undetermined what the sixteen-year-old girl had died from. It was believed that she died from the shock of finding her father dead.

From that night on, whenever a storm is approaching, a beautiful golden-haired girl dressed in a blue dress and wearing a coat is seen warning others of the impending danger by signaling with her arms to go back.

One couple picked up a young girl fitting that description. As the man drove, the lady in the front seat of the car turned around to engage the young girl in conversation, only to find that the girl was no longer in the car. The man turned the car around and headed back to the spot where he had picked up the girl to see if she had managed to get out of the car unnoticed. She was nowhere to be seen. The young girl had vanished. The backseat of the car was still wet where the rain-soaked girl had been sitting.

LAKE MURRAY MONSTER

Lake Murray is located near the small town of Irmo, South Carolina. Since the first sighting of the water monster in Lake Murray in 1933, Irmo has had a monster sighting almost every year. In 1933, Irmo residents claimed they saw a relative of the famous Loch Ness monster of Scotland.

The Lake Murray monster is simply known as Messie. In 1980, the *Independent News* described it as a cross between a snake and something prehistoric.

Many Lake Murray and surrounding area residents claim to have seen the lake monster. Some say that it's very aggressive. Others disagree.

Three people reported that while fishing in one of the many coves on Lake Murray, the monster charged at them. No one was injured, and the boat sustained no damage.

The South Carolina Wildlife Department claimed that the "monster" could have been a big alligator or maybe a sturgeon. The fishermen denied those claims, even though they did not get a good enough look at the creature to give a description.

So many sightings of a large fish or some other kind of water creature poured in that the South Carolina Department of Fish, Wildlife and Parks opened a file on it in 1990. Lake Murray biologist Harper was in charge of the incoming reports. Harper reported that he had talked to ten to twelve reputable people who reported having seen the monster. Harper said that in his twenty-plus years on Lake Murray, he has never seen the monster. He did report, however, that he found large, unexplainable holes in some of his nets when he was studying the habitat.

Military personnel, doctors, police and just regular people have reported seeing the Lake Murray monster.

The sightings fall into two categories: a large fish and a serpentlike creature.

According to reports, the forty-one-mile-long, fourteen-mile-wide, 380-feet-deep (at its deepest point) lake is big enough to sustain a supersized creature. There is enough biomass (biomass refers to living and recently dead biological material) in the lake to maintain a large creature.

In 1990, a retired United States Army general sent a letter to the South Carolina Department of Fish, Wildlife and Parks. The general stated in his correspondence that he and his son saw something in the water twice. It appeared to be forty to sixty feet long. The serpentlike monster had a head like a snake and a tail like that of an eel.

Another sighting occurred on September 15, 2002. Over the years, the monster has been spotted in all parts of the lake and during all four seasons of the year.

Local residents and experts disagree on what the Lake Murray monster really is. Many experts say it's just a big fish or an alligator. Local residents believe they have a monster in Lake Murray.

The owner of a local marine repair business reports that he and his wife have observed many wakes created by the Lake Murray monster. The monster has also circled their boat on occasion.

Another report from a swimmer stated that one time he stood up and felt as though he were standing on something. It was very bumpy and scaly. When he stood in the same spot about two minutes later, there was nothing there. No carcass or any type of remains have been found.

Meteorites

Cherokee Springs Meteorite

On July 1, 1933, at 9:42 a.m., a Saturday morning, a meteorite weighing just over thirteen pounds and measuring four inches by four inches by six inches blazed its way through the darkness of outer space. After passing through the atmosphere, it burned a path through the trees and buried itself in about two feet of dirt. The impact site was about forty feet from the Cherokee Springs Methodist Church. The church is located about six miles north of Spartanburg, South Carolina.

Mr. Swofford and Mr. Mayfield, proprietors of the local general store, dug it out of the ground. One of them reported that it was too hot to be handled for several hours after being removed from the ground. The unexpected arrival of the space rock was heard by everyone in the area. It was described as sounding like an airplane landing.

Mr. Johnson had a ringside seat for this spectacular event. He was cleaning off the graveyard near the church when the meteorite hit. It missed him by about three hundred feet. Mr. Johnson reported that he heard a noise and looked up to see the meteorite about two hundred feet in the air. The meteorite left a stream of blue smoke behind it as it passed through the air.

Mr. Whitesides was on his way to the Mayfield store to sell some chickens when the meteorite struck. He said he heard four sounds that sounded like blasts, then a swish.

Mayfield and Swofford were close to the spot where the meteorite struck. Mayfield said he heard a thud when it hit the ground. They went immediately to the location of the landing. The falling leaves showed them the impact spot.

Another meteorite hit Spartanburg County about the same time, in the corner of the barnyard belonging to Mr. Cash, near the Buck Creek Church. This one was about half as large as the Cherokee Springs meteorite, measuring about three inches by three inches by six inches and weighing about six pounds. Cash said the meteorite passed by with a hissing and crackling sound about fifteen feet above his head. It hit the ground at an angle, plowed a furrow in the ground about a foot deep, bounced out and rolled several feet. The stone was an olivine-hypersthene chondrite (amphoterite LL6). Analysis of the meteorite revealed that it was 20.38 percent iron.

The two meteorites fell six and a half miles apart that day.

Bishopville Meteorite

On March 25, 1843, a meteorite fell in Lee County near Bishopville, South Carolina. It fell over 160 years ago and is still fresh. The meteorite is classified as an aubrite achondrite. Aubrites are magmas that solidified inside the asteroid, and they contain some crystals. The following elements were found in the Bishopville meteorite: magnesium and sodium sulfate, calcium and magnesium

chloride, sodium and magnesium bisulfate and soluble silica. It weighed about thirteen pounds.

Study of the Bishopville meteorite indicates that it must have cooled very fast. The Bishopville meteorite is listed in the catalogue of meteorites in the National History Museum. Outside of the Antarctic, there are only ten aubrites.

Chesterfield County Meteorite

In 1849, in Chesterfield County a laborer on the plantation of an S.M. McKeown found the remains of a mass of meteoric iron. The plantation is situated in the Chesterfield district.

The meteorite was plowed up a few years before 1849. It was shown to a blacksmith, and about half of the meteorite was made into a pair of horseshoes, two hinges and some nails. About half of its original weight of thirty-six pounds was left. Its original shape was oblong, with one side and one end thicker than the other. The surface was indented and covered with rust.

The meteorite, iron hexahedrite, contained nickel, chromium, cobalt and nodular masses of magnetic pyrites. When the surface is polished and treated with diluted nitric acid, it reveals a great variety of beautiful figures and takes on a brilliant glow. Its etched surface distinguishes it from other iron hexahedrite meteorites.

Other South Carolina Meteorites

Listed here are several other meteorite impacts in South Carolina. Very little information is available on these.

In 1857, a meteorite weighing about 4.75 pounds was found in the northwest corner of Laurens County. It was iron cathedrae, fine.

In 1880, a 10.5-pound meteorite was found on a farm in Lexington County. It was iron cathedrae, course. This meteorite belongs to the group lllA.

In 1844, a meteorite weighing 117 pounds was found in Lexington County. This meteorite was iron octabedrite, medium. It belongs to group lllA.

STUMPHOUSE TUNNEL

There are several theories about how Stumphouse Tunnel got its name. One theory is that during the Civil War bootleggers would store their moonshine in a tree stump when it rained or to hide it from other people. Another story is from the Cherokee Indians, who claim they saw a couple living in a tree stump, over which the couple had built a roof. The Cherokees called it Stumphouse. Another story tells of the Choctaw or Creek Indian maiden Issaqueena, who was living with the Cherokee Indians. She overheard the Cherokees planning an attack on a group of white settlers. She rode to warn the settlers of the attack. The

Cherokees learned that she had warned the settlers and pursued her. Issaqueena and her white boyfriend, David Francis, hid in a stump to avoid the pursuing Cherokees. After the Cherokees located them, Issaqueena jumped from the waterfall.

The tunnel was first proposed in 1837 by residents of Charleston to provide a shorter route for the Blue Ridge Railroad between Charleston and the Ohio River Valley area.

The Stumphouse Mountain railroad tunnel was a southern industrialist's dream to connect the port of Charleston to the American Midwest. This innovative southerner proposed the railroad project in 1852. Three tunnels in western South Carolina would have to be constructed: the Saddle Tunnel, the Middle Tunnel and the biggest challenge of the three tunnels, the 5,863-foot Stumphouse Tunnel. The tunnel through Stumphouse Mountain would be a vital link in the railroad. One end of the tunnel would be several hundred yards above Issaqueena Falls.

Work on the tunnel began in 1856. The George Collyer Company of London, England, was contracted to build the tunnel. It brought in Irish workers for the tunnel project. Many of the workers lived in houses on top of Stumphouse Mountain, called Tunnel Hill. The tunnel through Stumphouse Mountain was never completed due to financial difficulties suffered by the company. In 1859, the tunnel was way over budget, with only 4,363 feet completed. By 1859, the State of South Carolina had

spent more than $1 million on the tunnel and refused to spend any more. The Middle Tunnel was completed but was closed by landslides. Neither the Saddle Tunnel nor the Stumphouse Tunnel was completed.

Before the company could recoup, the country had erupted in civil war. No work was done on the tunnel during the Civil War. After the Civil War was over, efforts made to reactivate the Stumphouse Tunnel project failed, and the tunnel was abandoned. There were three attempts to revive construction on the Stumphouse Tunnel: one in 1875, another in 1900 and the last in 1940. The unfinished Stumphouse Tunnel lay idle for eighty years after the Civil War.

In 1940, a professor from Clemson A&M College recognized the possibilities of curing blue mold cheese in the tunnel because of its year-round fifty-degree temperature and 85 percent humidity. The Clemson dairy department began experimenting with manufacturing blue cheese and curing it in the tunnel. In 1951, Clemson A&M College bought the tunnel and successfully cured the South's first blue cheese. The tunnel's environment was later duplicated at the college, and the blue cheese operation was moved there.

In 1970, the tunnel was leased to the Pendleton Historic District Commission, which turned it into a picnic area and tourist attraction. The entrance to the tunnel has become a historic landmark in South Carolina. The tunnel measures twenty-five feet high by seventeen feet wide and runs sixteen hundred feet into the heart of Stumphouse Mountain. About halfway down the tunnel is

a sixteen- by twenty-foot airshaft. It extends through the mountain sixty feet to reach the surface. In the mid-1990s, the tunnel was closed to the public after a rockslide. After safety tests were run by the City of Walhalla and the tunnel was declared safe, it was reopened to visitors in the park. The tunnel also has another attraction: it is home to hundreds of small brown bats.

In 2007, a developer proposed to purchase the property to create a new development. Many citizens and groups were against developing this property. After much work and money raised, the citizens and groups won. At the August 14, 2007 Walhalla city council meeting, the council members voted unanimously to place a conservation easement on the 440-acre watershed property, protecting it forever from development. The easement was signed by the mayor following the meeting and recorded the following morning.

It is said that strange occurrences have happened in the tunnel and that there are ghosts inside. Stumphouse Mountain is rumored to be the site of a big Cherokee burial ground.

Issaqueena

Issaqueena Falls are named after the Indian maiden Issaqueena, who jumped over the falls. The Creek Indian maiden fell in love with a white settler, David Francis, a silversmith who lived where the town of Ninety Six is now located. Although Issaqueena was not Cherokee, she lived

with the Cherokee Indians. After Issaqueena learned of
the Cherokees' plans to attack the white settlement, she
rode her horse to warn the white settlers. As she was riding
to warn the settlers, she mentally named the landmarks as
she passed along the trail. Mile Creek, Six Mile, Twelve
Mile, Eighteen Mile, Three and Twenty, Six and Twenty
and the last, Ninety Six. The creeks bearing these names
still exist. It was ninety-two miles from her starting point
to Ninety Six.

Issaqueena and her beloved David Francis fled to what is
now known as Stumphouse Mountain to escape her tribe.
They lived in a hollowed-out tree until they were tracked
down by the Cherokee Indians. Issaqueena, in order to
throw the Indians off David Francis's trail, fled to the
nearby waterfalls and jumped. She plunged out of sight.
The Indians, believing that Issaqueena had died from the
jump and the river had carried away her body, gave up the
search and returned home. Issaqueena later joined David
Francis, and they moved to Alabama.

Another version of the Issaqueena legend is that
Issaqueena Falls are named after a young Choctaw Indian
maiden whose real name was Kitichee.

A local Cherokee tribe held Kitichee captive in the
1700s. The Cherokees changed her name to Issaqueena.
Issaqueena met and fell in love with Allan Francis, the son
of a white settler who ran a trading post where Ninety
Six is now located. Issaqueena discovered the Cherokees'
plans to attack the settlers. She took one of their horses

and escaped from the Cherokees. She rode the horse to warn the settlers.

The settlers prepared for the attack, caught the Cherokees by surprise and killed many of the braves. The Cherokees found out that Issaqueena had warned the settlers of their attack. The braves chased her into the hills now known as Stumphouse Mountain. They caught up with Issaqueena at Cane Creek, just above where the creek flows over the waterfalls. Issaqueena, having no place left to run, jumped over the falls. The Cherokees, believing that Issaqueena was dead, returned home. The settlers believed that Issaqueena had landed on a rock ledge and hid behind the falls until the Cherokees gave up their search.

Big Foot

The earliest recorded sightings of a big foot creature date back to the sixteenth century. They started with sightings by American Indians. Big foot is a big, hairy creature that looks more like a six- to eight-foot-tall man than an animal. It walks and runs on two legs just like a human. It is not aggressive and doesn't seem to be dangerous. Many reports say that the creature has eyes that glow in the dark. Many reports say that big foot emits an apelike grunt and growls. The giant creature has more than fifty names, which include big foot and sasquatch. What name is used depends on where you are.

Daufuski Island Big Foot

When darkness is slowly creeping in on Daufuski Island, residents' and visitors' imaginations may start to run wild. Their heads fill with thoughts of ghouls, goblins and other things that make their way out under the cloak of darkness. Big foot is said to make its way in the darkness on this remote island, which you can only reach by boat. Big foot has been sighted on Daufuski Island and is believed to live there.

From Mount Everest to the swamps of South Carolina, people have reported seeing a big, hairy creature they call big foot. Professional hunters, paranormal investigators and other investigators with all types of sophisticated equipment have put much effort into locating big foot. To this day, no one has had any success in locating big foot or any remains.

Three men spotted what they believed to be big foot going through the marshes at Moss Creek Plantation on U.S. 278, just before you cross the bridge to enter Hilton Head Island.

Neeses Big Foot

There are conflicting reports on whether the person who saw this big foot was male or female. At about twelve noon on July 15, 1997, Hutto heard a lot of barking from the dogs that were kept in a pen on the back of the

family property. Hutto yelled at the dogs to quiet them. The dogs continued to bark, so Hutto went out to see what was causing the dogs' unrest. Hutto, nearing the pen, saw a large, hairy animal pulling on the fence wire. Hutto walked closer to get a better look. The animal appeared to be eight to eight and a half feet tall with brown hair. The animal turned its whole body, not just its head, and looked at Hutto. Hutto screamed, and the animal ran into the woods. Hutto could hear it grunting as it ran off. The animal's face was bald and humanlike with brown-colored skin. Its teeth were big, block-shaped and discolored. It had huge eyes about the size of a horse's eyes. Hutto did not try to find any evidence of its appearance right after the sighting. It rained that night, and no evidence was found the next day. Neeses is located in Orangeburg County.

Williamsburg County Big Foot

A motorist driving home to Columbia from Georgetown on Highway 521 about 12:00 a.m. reported seeing something that looked like a fox standing on the side of the road. Just before the car reached the spot where the creature was standing, the animal started to run across the road. It was followed by something big, dark and shaggy. At first, the larger creature stood still at the side of the road, and then it leaped across the highway and ran into the woods.

It appeared to have short reddish/auburn hair and was about six or seven feet tall. The creature moved on two feet like a human would. It appeared to be manlike in appearance, kind of slender and not thick like a bear. Its amber-colored eyes glowed when it looked at the car, and the lights reflected off its eyes as it headed toward the woods. The driver reported smelling something like a dead animal just before he saw the creature.

Catawba River Big Foot

Three friends were fishing one afternoon near the Catawba River. They kept hearing a rustling sound coming from nearby bushes. They thought it was a raccoon or opossum and ignored it for a while. They heard it again as they were preparing to leave, and one of the friends looked over in the direction of the sound. He saw a large figure standing on two legs about thirty yards from them. When he alerted the others, the hairy animal ran into the woods, but not before the others got a good look. They gave chase after the animal but failed to catch up with it as it disappeared into the woods.

NUCLEAR BOMB HITS MARS BLUFF

A broken arrow (code word for a military accident involving a nuclear weapon) hit Mars Bluff, South Carolina, on March

11, 1958, at 4:19 p.m. The unarmed nuclear bomb was accidentally dropped by a United States Air Force B-47E Stratojet, a medium-sized bomber, serial number 53-1876A. The bomber was from the 308th Bombardment Wing (a second report says 375th Bombardment Squadron) in Savannah, Georgia. While en route to the United Kingdom for Operation Snow Flurry, a nuclear bomb was dropped in the woods near a farmhouse owned by the Gregg family.

The nuclear bomb measured ten feet, eight inches long and sixty-one inches in diameter and weighed seventy-six hundred pounds. The nuclear material was not in the bomb at the time it was dropped.

That afternoon, the Gregg sisters, one six years old and the other nine, and their cousin, also age nine, were playing in their playhouse near the edge of the woods. Tired of playing and looking for a new adventure as small children will, they moved about two hundred feet to the side of the yard. About nineteen minutes after they left the playhouse, a United States Air Force bomber dropped the weapon in the woods behind the Greggs' house. The children's decision to move to another location to play kept them from being the first casualties of a nuclear weapon released on United States territory.

Mrs. Gregg was sewing in the parlor; her son and his father were in the toolshed working. The family members were taken to the hospital in Florence, South Carolina. The cousin received thirty-one stitches and was kept overnight. The Gregg family was released with minor injuries. The

Gregg family knew it was an explosion of some kind but didn't learn until that evening that it had been caused by a bomb dropped by a United States bomber. Five months later, the air force awarded the Gregg family $54,000.

At eight o'clock in the morning on March 11, 1958, pilot Captain Koehler, copilot Captain Woodruff, navigator/bombardier Captain Kulka and crew chief Sergeant Screptock arrived at Hunter Air Force Base. Their assignment was to fly their B-47E bomber in Operation Snow Flurry. Operation Snow Flurry was part of a unit simulated combat mission and special weapons exercise.

Aircraft 53-1876A was accompanied by three more B-47s from the 375th Bombardment Squadron and was to carry a nuclear weapon to Bruntingthrope Air Force Base in England for a special nuclear weapons exercise.

The crew had problems setting the locking pin that holds the bomb in the plane until it is ready to be dropped. They had to use a hammer to complete the pin engagement. During their haste to complete the preflight checklist, they failed to check the release mechanism of the pin.

The policy of the air force requires that the pin be released before takeoff and then reinserted at five thousand feet. The B-47E bomber departed Hunter Air Force Base in Georgia as the number three aircraft in a flight of four United States Air Force planes headed to an overseas base. The pin was released at takeoff, and as the plane reached five thousand feet, the copilot operated the lever to reinsert the pin. A cockpit warning light alerted

the crew that the pin was either not set or a malfunction had occurred.

Bombardier Kulka, who was responsible for the bomb, was instructed to go into the bay and find out what the problem was. Kulka entered the compartment and grabbed what he thought was the pin, realizing too late that it was the emergency-release lever. Kulka pulled the lever, and the bomb dropped onto the bomb bay doors. Kulka fell on top of the bomb; the weight from both caused the doors to open, and the bomb fell. Kulka managed to hold on and pull himself back into the plane. He radioed the pilot about what had happened. The pilot transmitted a special coded message to Hunter Air Force Base. The air force base did not recognize the transmission because it had never been used before. The pilot had to radio the Florence Airport and have it call Hunter Air Force Base to explain that aircraft 53-1876A had lost a device.

The high-explosive trigger in the unarmed nuclear bomb exploded on impact in a sparsely populated area in Florence County. The explosion left a crater seventy feet in diameter and thirty-five feet deep, virtually destroying the Gregg family home, five other buildings and the family car. A church also sustained damage.

The cleanup required several days to complete. The air force recovered hundreds of pieces of bomb fragments carried off by local residents. The residents of Mars Bluff were examined for several months to see if they had been exposed to radiation.

THE PHANTOM HORSEMAN OF COLUMBIA

In the spring of 1914, a man was walking with his dog down Lady Street, not too far from the statehouse. He had left his daughter's house after one of his many visits. He and his collie were walking alone near the corner of Bull and Blanding Streets. The streets were deserted, and most homes were dark, as the hour was late.

The collie began to bark and slowed its pace. Not wanting to wake anyone up, the man spoke to the dog and petted him a little. The dog hushed his barking and continued walking beside his owner. Just before they reached the corner of Bull and Blanding Streets, the dog began to bark again. This time, he stopped and would go no farther. The man wondered what could be making the dog bark. The dog had never acted like this before. He wondered if the dog could be afraid of the full moon.

The man searched the surrounding area but saw nothing out of the ordinary. His eyes moved up toward the sky, and as he looked toward the corner of Bull and Blanding Streets, he saw, high above the tops of the giant oak trees, the ghostly figure of a man riding a horse. It was sharply defined, shining white and clearly visible above the trees. The phantom horse and rider were gigantic. Every detail—the saddle, the reins, the bridle and even the horse's flowing tail—was sharply defined. The man could pick out every detail of the clothes worn by the rider. As he stood there in amazement,

the horse reared up its front legs as if heading to some far-off place.

As the man watched the ghostly figure, he became aware that he was not alone. A couple was walking down the other side of the street. He saw the man point upward and then say something to the lady. The couple stood there for a moment and then hurried away as if they were frightened.

As he walked home, the man could not figure out what it was that he had just witnessed. He lay down to sleep, but sleep would not come easy that night. The next morning, he was awakened by the glow of the early morning sun. He thought about what he had seen and realized it must have been a nightmare. Phantom horsemen don't exist.

That evening, when he arrived at his daughter's house, he could tell something was different. His daughter seemed very excited about something. When he asked what she was excited about, she told him that everyone was talking about the ghostly horseman above the trees at the corner of Bull and Blanding Streets. He told her that he had seen it last night but thought it was just a dream. She asked if he would walk to the corner with her and her husband to see if it would appear again. They arrived at the location where he had seen it the previous night. A crowd had already gathered to witness the ghostly apparition should it make another appearance. They waited more than half an hour before the phantom rider appeared.

Someone in the crowd shouted, "It's one of the four horsemen of the Apocalypse!" (The four horsemen of the

Apocalypse are biblical figures foretelling the coming of the end of the world.) The four horsemen will appear when Jesus opens the first four seals of a scroll with seven seals. The fourth horse was a pale horse, and its rider was called Death. The four horsemen of the Apocalypse are the forces of man's destruction described in chapter six of the Book of Revelations. The four horsemen are traditionally named for the powers they represent: Conquest, War, Famine and Death. These names are open to interpretation. The Bible only names the fourth, Death. Another person in the crowd shouted, "It's the angel Gabriel come to blow his horn!"

After several minutes, the clouds slowly covered the moon, and the phantom horseman slowly faded into darkness. The man, his daughter and her husband headed back to her house. After returning home that night, the man could not get it out of his mind how much that phantom horseman looked like General Wade Hampton. Many believed it was the ghost of General Hampton returning to warn people of the upcoming world war.

Wade Hampton was born to one of the richest families in the antebellum South. He owned plantations in Mississippi and South Carolina. Hampton was a Confederate lieutenant general, a United States senator, a South Carolina governor and a South Carolina senator. Hampton was born in Charleston on March 28, 1818. He died in 1902.

The phantom horseman of Columbia bears a striking resemblance to sightings of angel horses in early Jewish history.

ELLENTON, SOUTH CAROLINA

Ellenton was established about 1870. The settlement began with the construction of the Port Royal and Augusta Railroad. Many people moved into Ellenton to work on the railroad. The Port Royal and Augusta Railroad was later renamed the Charleston and Western Carolina Railroad. This railroad is now part of the CSX Transportation System. Robert Jefferson Dunbar granted a right of way through his plantation for the railroad, the train station and the town. As the railroad grew, the town grew. One could hear the gleeful chatter of children playing in the streets and could smell the aroma as the wives cooked dinner for their working husbands.

Stephen Caldwell Millet, superintendent of railroad construction for the Port Royal and Augusta Railroad and president of the railroad, lived with the Dunbar family during most of the construction of the railroad and town. Millet was so impressed with the beauty of nine-year-old Ellen Dunbar that he asked the company to name the train station Ellen's Town. Another source says that Ellen Dunbar was twenty-two years old in 1870.

The town of Ellenton was incorporated in 1880. It was primarily an agricultural and sawmill town. By the early 1950s, Ellenton had a population of about 760, about 190 residences, thirty commercial buildings, five churches, two schools, a cotton gin, a city hall with a jail in the building and the railroad station.

Ellenton was the first town in South Carolina to have the automatic telephone dialing system. After the Great Depression and the bank failures, Ellenton was the first cash depository in South Carolina.

In 1945, the beginning of the atomic age arrived with the bombing of Hiroshima and Nagasaki. The most powerful weapon on earth was unleashed on these two cities, causing total destruction and costing many thousands of innocent lives. In 1950, President Truman approved the selection of a site in South Carolina along the Savannah River for the Savannah River Plant. The government had asked DuPont to build and operate a plutonium production plant. DuPont had unparalleled expertise in the atomic energy field.

On November 28, 1950, the United States Atomic Energy Commission and the DuPont Company announced that they would be building the Savannah River Plant on about three hundred square miles of land. This amount of land was required due to the possible hazards of radiation. It would be located in Aiken County, Barnwell County and Allendale County. The Savannah River is a major river in the southeastern United States. It forms most of the border between South Carolina and Georgia. The plant was being built for the production of plutonium and tritium, critical ingredients for the hydrogen bomb.

About six thousand people would have to be relocated to give the government the necessary amount of land.

This included the incorporated towns of Ellenton and Dunbarton and the outlying communities of Hawthorne, Myers Mill, Robbins and Leigh. Many of these residents were farmers and sharecroppers, and many moved to the new town of New Ellenton, located on U.S. Highway 278. The government either bought or condemned their properties. About six thousand graves also had to be relocated.

All that is left today are a few buildings, a few homes, the streets, the farms and the spirit of the former residents. If one could get back into Ellenton, he or she might see and hear the spirits of the residents as they unhappily left their homes—children still at play, men working and ladies cooking. These are not the ghosts of the dead but the memories of unhappy people.

MARY INGELMAN, WITCH OF FAIRFIELD COUNTY

When someone mentions witches, our thoughts often turn to Halloween and an ugly old hag dressed in black, wearing a pointed hat and flying on a broomstick at midnight. Or they might turn to an ugly old lady standing by a big black cauldron over a fire, stirring some evil potion.

Television portrays witches in many different ways, from the beautiful Samantha to the old wicked witch. Some cast spells by pointing their fingers and chanting some unknown verbiage, while others use potions.

When one hears of the witch trials, one immediately thinks of Salem, Massachusetts, not Fairfield County, South Carolina. It was thought that there were no other witch trials after the ones in Salem in 1692. Records in South Carolina seem to prove that wrong. The *South Carolina Gazette* published a story on November 10, 1792, about the cruel beating of four (or five, depending on the source) people accused of practicing witchcraft. This is the case of Mary Ingelman, the witch of Fairfield County. The details of this trial are recorded in the court records of Fairfield County.

One source says it was Mary Ingelman, Old Man Hending, Sally Smith and Joe Fairs who were practicing witchcraft. Another source names Mary Ingelman, John Erric, Benjamin Owens and Hezekiah Hunt and his wife, Mourning Hunt. The accused were charged with casting evil spells on Rosy Henley and her sister. Rosy accused Mary Ingelman of casting a spell on her that made her levitate so she could not be held down.

In 1792 in Fairfield County, strange things were happening to the local people. Many people began to act possessed, and many cattle got sick.

Adam Free, son of Lawrence and Mary Free, testified that Mary Ingelman caused one of his cows to fly into the air and then fall back down to the ground and break its neck. Jacob Free, son of Adam Free, testified that Ingelman turned him into a horse and rode him for six miles. Isaac Collins testified that Ingelman turned him into a horse and rode him to a witch's convention that the devil himself

attended. Martha Holly testified that Ingelman had also afflicted her.

Those accused of practicing witchcraft were taken from their homes by force. They were taken to the Hill Farm five miles south of Winnsboro, South Carolina. Hill was chosen as the judge in this illegal witch trial. The sheriff

and executioner were one and the same, a man named John Crossland.

The only evidence presented were written accusations from the people who claimed they were affected by witchcraft. No eyewitnesses or proof were entered into the records. The accused could offer no defense and were found guilty of practicing witchcraft.

For their punishment, they were tied to the joists of the building and flogged severely. Then their feet were held to a bark fire and burned until the soles popped off. After the heinous torture, they were let go.

Mary Ingelman persuaded judge William Yongue to issue an arrest warrant for John Crossland. Crossland was served with the warrant, arrested and taken to court. Crossland was found guilty of aggravated assault and fined five pounds. The fine was never paid, and he left the county after his trial. Crossland was never heard from again.

ANNE BONNY

Pirates, those swashbuckling bad guys of the sea, date back more than three thousand years. To many people, pirates lived glamorous, adventurous lifestyles that included sailing the seven seas, attacking other ships, capturing crews and stealing treasure.

There were very few female pirates. Those who did exist dressed like men to keep from being discovered.

Anne Bonny is a historical figure. She was one of the best-known female pirates in history. Whether she was a little headstrong, an independent lady or a common criminal, Anne Bonny was far ahead of her time. Anne's exact date of birth is not known, but it is believed to have been between 1697 and 1700. Some believe she was born on March 8, 1700. She was born illegitimately to Mary (Peg) Brennan, a maid in Anne's father's employment in Kinsale, County Cork, Ireland.

Anne's father, William Cormac, a practicing attorney in Kinsale, had his practice ruined when his wife made public his adulterous affair with his maid, Mary Brennan. Cormac and his wife separated shortly after the affair was exposed, and Cormac decided to raise Anne himself. Cormac, after having his law practice ruined, finally had to leave Ireland in disgrace. He took Anne and Mary Brennan to America. The family settled in one of the colonies in Charles Town (now Charleston), South Carolina. Charles Town was a large shipping community at the time they arrived.

Cormac presented Mary Brennan to the social community as his wife and Anne as their daughter. Cormac started a new law practice in Charles Town and was very successful. Another source says that Cormac prospered as a trader. Cormac was soon prosperous enough to buy his own plantation near Charles Town. His family was accepted by the social elite of the community.

After Brennan died, Cormac raised Anne alone. Anne proved to be a wild teen with a fiery temper. She was a real challenge for Cormac. She grew up with a reputation of

being violent, savage and courageous. At the young age of fourteen, while most girls were enjoying their teenage lives, Anne had the task of running her father's household. One of the many stories that surround Anne Cormac tells of how she got into a violent argument with one of the servants and stabbed and killed the servant. Another story tells of the time she thrashed a young man so severely for trying to sexually assault her that he had to remain in bed for several weeks to recuperate. Anne was just fourteen at the time.

At sixteen, Anne fell in love with a sea captain, James Bonny, whom she had been seeing without her father's permission or knowledge. Cormac hoped that Anne would marry an ambitious young man and take her place in Charles Town society. That wasn't going to happen. Anne's eyes fell favorably on James Bonny. Her father objected to the romance, but Anne refused to stop seeing James Bonny. Cormac thought Bonny was just a fortune hunter looking for a quick fortune by marrying Anne and thus cut her out of his will.

Anne and James Bonny eloped in 1716 and headed to New Providence, Bahamas. New Providence was well known for being a notorious pirate enclave or den of iniquity. Bonny earned money acting as an informant, turning in pirates for the reward. Anne and James Bonny's union was short-lived. She became romantically involved with Chidley Bayard, a wealthy merchant.

In 1718, Governor Rogers offered an official pardon to all pirates if they would surrender to the authorities in the Bahamas. The first pirate to take advantage of the offer

was Captain John "Calico Jack" Rackham. Rackham was nicknamed Calico Jack for his flamboyant clothes. He was said to be the first pirate to fly the skull and crossbones on his ship. Bonny met Rackham, and they began seeing each other.

When James Bonny found out about his wife and Rackham's affair, he reported it to Governor Rogers. Rackham offered to buy Anne's freedom, but James Bonny refused. Governor Rogers ordered Anne to go back to her husband or she would be flogged in public. Instead of returning to her husband as ordered, Anne ran off with Rackham.

Bonny and Calico Jack gathered a crew of pirates and stole a ship, the *Curlew*, to prepare for their careers as pirates. This made Bonny one of the few known female pirates in maritime history. Bonny found out that she was pregnant. This cut her career as a pirate short. She and Calico Jack went to Cuba for Bonny to have the baby, but the baby was stillborn. Bonny and Calico Jack recovered from the loss of their first child while in Cuba.

When they returned to the sea, Bonny met female pirate Mary Read, who had joined the group dressed as a man. The trio later seized a British merchant ship, the *William*. Governor Rogers declared Rackham, Bonny and Read to be pirates and enemies of the Crown and sent out armed ships to hunt them down.

The *William*, anchored in Negril Bay, was spotted by Captain Charles Barnet one evening. Barnet fired at the *William*, destroyed part of the sail and rendering it helpless. Most of the pirates were too drunk to put up any kind of resistance against Captain Barnet and his crew. Bonny, Read and one other pirate fought back viciously, but with no success. In the end, all were captured and returned to the port of Spanish Town, Jamaica, to stand

trial. Rackham and the other pirates were found guilty of piracy and sentenced to death. On November 16, 1720, Bonny and Read's trial was held at Spanish Town's court. On November 28, 1720, both were found guilty and sentenced to death. Bonny and Read claimed to be pregnant. This delayed the execution until the pregnancies could be proven. Both were found to be pregnant and sent to prison. Mary Read died in prison from a fever on December 4, 1720. Bonny gave birth in prison.

A letter from Governor Rogers gave Bonny her freedom. Her father, back in Charles Town, bribed the Jamaican officials to return Bonny to Charles Town. Bonny, after returning, wed Joseph Burleigh in 1721. Anne Bonny Burleigh and Joseph Burleigh had five children.

Anne Burleigh died at the age of eighty-one on April 25, 1782. She is buried at the York County Cemetery in Virginia.

POINSETT BRIDGE

Poinsett Bridge, an old rock bridge, is located in northern Greenville County on Callahan Road, formally Old Highway 25 North, near the state line. It is believed to be the oldest surviving bridge in South Carolina. Poinsett Bridge reaches 130 feet over Little Gap Creek. It features a 14-foot Gothic-style arch and was named after Joel Poinsett. Slave labor constructed the bridge under the direction of Joel Poinsett.

Most historians believe that Robert Mills, not Joel Poinsett, designed the bridge. Robert Mills designed the Washington Monument in 1836. He designed the courthouse in Kingstree. Mills was born in Charles Town on August 12, 1781. He died in Washington, D.C., in 1855 and is buried at the Congressional Cemetery.

Poinsett was the first United States minister to Mexico. Poinsett was also secretary of war in the cabinet of President Martin Van Buren. Poinsett was South Carolina's first commissioner of public works. Poinsett, a Charles Town native and an early prominent resident of Greenville, introduced the poinsettia flower to the United States. He brought it back from Mexico. The flower was named the poinsettia in his honor.

The Gothic arched stone bridge is no longer in use but is still intact. Poinsett Bridge is now part of a 120-acre Heritage Preserve and is listed on the National Register of Historic Places.

The bridge is reported to be haunted by the ghosts of the slaves who died during its construction. Another legend says that a slave was hanged under the bridge and his ghost still haunts it. The ghosts of the slaves appear as lights in the nearby woods; sometimes they can be seen on the bridge after dark. They float in the air and then vanish. Local residents have reported loud screams when they get to the lights.

Another story states that an old Indian burial mound was located near where the bridge was built and was destroyed

by careless workers during the construction of the bridge. Is it possible that the souls of the dead Indians whose graves were desecrated during the construction of Poinsett Bridge have come back to haunt the bridge? Motorists have reported having trouble starting their cars when they see the lights.

Georgetown, the Ghost Capital

A TV reporter once referred to Georgetown County as the "Ghost Capital of the South." With over one hundred ghost hauntings in the area, no wonder it earned that title! Why are so many ghosts present in this area? Some say they're products of strong romances in the antebellum era. Some of the greatest stories of romance come from this time. Many of these romances went wrong—a loved one went off to sea and never returned, leaving a brokenhearted lover alone. Many waited on their lovers until their own deaths. And even after death, many have returned, still waiting for their lovers' return. Some say it was the sudden and often-violent death associated with seafaring life that produced the ghosts. Many young men lost their lives when they went out to sea. Others say the ghosts were products of loved ones heading off to war only to be killed, leaving grief-stricken lovers behind, or of plantation owners returning after death to watch over their homes and plantations.

Georgetown holds a unique place in American history. Some historians believe that American history began here in 1526. It is believed that this was the earliest European settlement in North America. In 1526, the original Spanish

settlers established a colony at the head of Winyah Bay but were driven out by disease.

In 1729, a Baptist minister founded Georgetown. Georgetown quickly became a commercial center for the Lowcountry. It is in a strategic location on Winyah Bay, where three large rivers meet: the Great Pee Dee River, the Waccamaw River and the Sampit River. Georgetown is the second-largest seaport in South Carolina.

Georgetown played a large part in the American Revolutionary War by sending Thomas Lynch Sr. and Thomas Lynch Jr. to the Continental Congress. Thomas Lynch Jr. was one of the signers of the Declaration of Independence.

British troops occupied Georgetown from July 1780 to May 1781. Many skirmishes between the "Swamp Fox" Francis Marion and British troops took place in Georgetown County. Georgetown was an important port for supplying General Nathanael Greene's army.

After the Revolutionary War, Georgetown's economy boomed. This was due to rice becoming a major export. Rice quickly became a staple crop around the Georgetown area on its rivers. By 1840, the Georgetown area produced nearly half of the rice crop in the United States. Rice continued to be grown commercially until about 1910. After the Civil War, many plantation owners lost their fortunes, and the rice industry almost disappeared. Georgetown turned to wood products for economic survival after Reconstruction ended.

After the twentieth century dawned, Georgetown began to modernize. It added electricity, telephones, rail connections, paved streets, banks and many other businesses. Georgetown also had a thriving shipping port.

During the Great Depression, Georgetown suffered great economic privation. While many small businesses went under, the biggest impact on Georgetown was when the Atlantic Coast Lumber Company went bankrupt, leaving many Georgetown and area residents out of work.

In 1936, the Southern Craft division of the International Paper Company opened a paper mill in Georgetown. By 1944, it was the largest paper mill in the world. Paper and steel industries have moved to Georgetown. Tourism has become a booming business. The Historic District contains over fifty homes, public buildings and sites listed on the National Register of Historic Places. Georgetown is the third-oldest city in South Carolina and the second-largest seaport in the state.

Few, if any, areas in the United States contain more history, charm and good old southern hospitality than Georgetown. Since the beginning, Georgetown has been known for its hospitality and Old World southern charm. Several companies offer guided ghost tours in Georgetown.

PREHISTORIC PETROGLYPHS

In the uppermost part of South Carolina, where the waters of Lake Jocassee splash against the Blue Ridge Escarpment,

prehistoric petroglyphs can be found. The Blue Ridge Escarpment represents the transition between the Carolina mountains and the piedmont. Steep, forested slopes drop by two thousand feet vertically in a very short distance of one to two miles. A group of steep-sided gorges carrying rivers and streams down to the piedmont has cut the steep-sloping face of the escarpment. These gorges are known as the Jocassee Gorges. Ten streams—the Saluda, the Laurel Fork, the Thompson, the Bearcamp, the Toxaway, the Eastatoe, the White Water, the Horse Pasture, the Chattooga and the Devil's Fork—have carved these gorges and created some of the most scenic and beautiful waterfalls in the state.

A local hunter had been hunting the woods of Jocassee Gorges for more than thirty years before he discovered the petroglyphs.

Thousands of years ago, perhaps even longer, people sat on Pinnacle Mountain. No one knows what drew them there or what the place was used for. It may have been a place of worship or just a place of pilgrimage for silent meditation. What brought them there and what they did after they got there is as much a mystery as the petroglyphs they left behind. We may never know who these people were and what their purpose on Pinnacle Mountain was, but they left their mark on the mountain.

Finding the petroglyphs on Pinnacle Mountain was an added bonus. Pinnacle Mountain is part of a thirty-three-thousand-acre Jocassee Gorge tract purchased by the state for preservation.

The recent discoveries on Pinnacle Mountain are still clouded with mystery. Who made the markings, why they made them and the exact date they were made is still speculation.

Archaeologists think that they were made long before the Cherokee Indians' time—perhaps thousands of years ago, in the Archaic Period. Unlike historic carvings, which usually have recognizable symbols, those on Pinnacle Mountain do not. The symbols on Pinnacle Mountain can't be tied to any historic period.

Archaeologists think the petroglyphs are prehistoric due to the amount of erosion. Hundreds of these petroglyphs are carved into metamorphic rock, also known as gneiss. Gneiss is a type of rock formed by a high-grade regional metamorphic process from preexisting formations that were originally either igneous or sedimentary and most commonly formed on ancient seabeds. Gneiss is a high grade of metamorphic rock.

In one location, the geometric designs are circles and ovals ranging from the size of a chicken egg to as big as a man's hand. Another group of shapes resembles a tiger paw. All but one face west. More questions are being raised as more petroglyph discoveries are made. Less than a mile away, at a resort near Table Rock in Pickens County, nearly two hundred petroglyphs were found on a single rock. These petroglyphs were rectangular, P-shaped and in the shape of a horseshoe.

Last year, a rock was found on a remote mountainside in northern Pickens County. Archaeologists think the rock

contains an ancient pictograph or some type of drawing. Pickens County has more petroglyphs than the other counties. Greenville, Laurens and Oconee Counties have yielded some good finds. Until 2000, only six petroglyphs had been found in the state.

This region has drawn scientists for centuries. In the mid-1700s, scientist William Bartram discovered the flame azalea. He also discovered other species. In 1787, botanist Andre Michaux discovered a plant now known as Oconee bells.

Jocassee, according to Indian legend, means "Place of the Lost One." Two Indian tribes inhabited the area, Oconee and Eastatoe. The Eastatoes were known as the Green Birds and probably got their name from the Carolina parakeet. The Carolina parakeet is the only parrot native to eastern North America. The last site where scientists recorded a sighting of the Carolina parakeet was in the Eastatoe Valley in South Carolina in 1904.

THE BOO HAG

The legend of the boo hag comes from the Gullah culture found in South Carolina. The slave culture known as Gullah left a lasting impression on South Carolina folk tales from the Lowcountry. Many of the Gullah beliefs and superstitions have continued to this day.

According to legend, boo hags are similar to vampires. But there are several different characteristics. The boo hag doesn't suck human blood and is far more frightening than the vampire. A boo hag steals energy by stealing her victim's breath. She does this by riding her victim. A common expression in South Carolina's Lowcountry is "don't let the hag ride ya."

Boo hags are blood red and don't have skin. They feel warm when touched and are hard to hold on to. Due to their very noticeable appearance, boo hags often disguise themselves inside the skin of a person as long as the skin holds out. In this disguise, a boo hag can go about her work of choosing her next victim.

In order for boo hags to ride someone, they must first get out of their previously stolen skin. Once a victim has been chosen, the boo hag will hide her old skin. The boo hag enters her victim's home through any little opening. Once inside the house, the boo hag searches through the rooms until she finds the bedroom where the intended victim is sleeping. Once the victim is located, the boo hag will place herself over the person and begin sucking his or her breath. (This is much like the legend of the cat sucking a baby's breath.) The victim will slip into a dreamlike state, rendering him or her helpless. As long as the person remains asleep, the boo hag will suck the breath and leave. If the victim does not wake up, there is little chance of death.

However, people have been known to wake up while the boo hag is riding them. This is very dangerous, since the

boo hag may decide to take more than just breath. They may leave you skinless!

The Gullah are known for preserving more of their African linguistic and cultural heritage than other African American communities in America.

SENECA GUNS, SONIC BOOMS OR SKYQUAKES

Seneca guns and skyquakes are just names, not explanations, for the noises heard over the coast of South Carolina. The air force denies any knowledge of the booms. The navy says it is not responsible for the noises.

Military aircraft have been known to cause sonic booms. Military aircraft are allowed to reach supersonic speeds and break the sound barrier if they are over the ocean, at least ten thousand feet up and at least fifteen miles off shore. Aircraft need to be flying seven hundred miles an hour to create a sonic boom.

Naval ships firing their guns off shore could produce some of the booms if the atmospheric conditions were right. The navy says there were no ships in the area firing guns at the time of the noise. There is one flaw in the theory of the military causing the sonic booms: the Seneca guns were heard as far back as the 1800s off shore of Lake Seneca in New York.

Seismologists investigated the sonic booms but were unable to determine the cause. Earthquakes are a possible

explanation, but no earthquake has been recorded on seismographs. Seismographs are the instruments that record the ground shaking during an earthquake. A seismologist in Virginia has tried to match the Seneca guns with seismograph records, but to no avail.

If you like ghost stories, here's one: some people say the noises are the ghosts of dead Indian braves firing guns to disturb the descendants of the white settlers who took their land.

On December 14 (year not listed), a loud boom was heard in Myrtle Beach. The sound was so loud that it shook windows inland. The air force stated that it did not have any planes in the area at the time of the sonic boom. During the week prior to August 2, 2003, a sonic boom was heard near Charleston. Seismologists in Columbia and Charleston examined their seismographic records for the time of the boom and found no indication of an earthquake.

Another boom occurred that rattled the Lowcountry. It was heard as far as Mount Pleasant and James Island. Charleston Southern University and the University of South Carolina ruled out any earthquake tremors. No record was found on the seismographs.

Sonic booms continue to plague the East Coast. On January 25, 2003, at about 10:00 a.m., residents all over Beaufort County heard a low, long rumble. Some residents reported that they felt the ground shake. No earthquake tremors were reported in that area. A sonic boom was heard from John's Island to the Isle of Palms and McClellanville along the coast and as far inland as Nesmith. The

National Earthquake Information Center says this was no earthquake. There were no seismographic records at that time showing any earth movement.

On December 14, 2004, at 7:45 p.m., there were reports of a loud rumble heard over Myrtle Beach. The sound lasted about thirty seconds. No one reported any windows shaking. On Wednesday, September 5, 2007, a sonic boom was heard in the North Myrtle Beach area. On October 18, 2007, at 10:02 p.m., a loud boom followed by a white flash was heard over North Myrtle Beach. Several people reported seeing two yellow lights shortly after the boom. About sixteen minutes later, it happened again.

I don't remember the year or time, except that it was in the afternoon. I was on the beach at Huntington Beach State Park photographing a model when I heard a sonic boom. The sky was overcast, but there was no sign of a thunderstorm. I did not observe any planes flying at that time.

SOUTH CAROLINA'S OWN PTEROSAUR

Is it a bird or a plane? No, it's a pterosaur.

In 1989, at about 3:00 p.m., a motorist traveling on Highway 40 from Greenville to Florence observed a giant flying creature glide gracefully over the highway in front of her car. The motorist first saw the flying creature at about treetop level. It flew down over the highway and across the

motorist's car and then up over the pine trees. It looked as though it was gliding but slowly flapped its huge wings several times. The motorist reported that it was about as big as a car and appeared featherless. The wing span looked about twenty feet across. The sighting occurred in a remote, swampy area of South Carolina.

The motorist could not stop because her friend had continued driving on and they would have been separated. The friend was driving ahead of her and did not see the winged creature. Many cars on the other side of the road pulled over after they observed the creature.

Could a giant flying creature still live undiscovered in the swamps of South Carolina?

Throughout history, fascinating reports of living pterosaurs have emerged from various parts of the world, from the fiery flying serpents of the Bible to the pterodactyls in England. The twenty-first century brought reports of giant flying creatures resembling pterosaurs in Papua New Guinea.

These flying creatures range in size from a sparrow to the size of an airplane. Pterosaurs ruled the skies during the Jurassic and Cretaceous periods.

Ghost Soldiers of the Confederacy

A woman who made a little money to help her family as a laundry girl moved to Charleston shortly after the Civil War, not knowing what was in store for her. Sleepless

nights and the sound of marching soldiers would haunt her every night. She found herself awakened at twelve midnight every night by the noise of heavy wheels passing on the cobblestone street. She lived on a dead-end street, so where were these wheeled vehicles going? There was no explanation for the noises she heard each night.

Her husband would not let her go to the window and look out when she heard the sounds of the wheels. He told her it was better to leave things alone.

One day while she was washing clothes, she asked the woman next to her tub about the sound she had been hearing. She explained that she began hearing it when she moved to Charleston and heard it at midnight every night. She told the woman that her husband would not let her look out of the window. The woman told her that she was hearing the ghost soldiers of the Confederacy; some people called it the army of the dead. The soldiers were Confederate soldiers who died in the hospital and never knew the Civil War was over. They were scheduled, before their deaths, to march out at midnight to reinforce General Lee's weakened Southern forces in Virginia. The woman told the laundry girl that each night at midnight the soldiers rise up from their graves and start marching to Virginia.

One night shortly after this conversation, the laundry girl slipped out of bed without waking her husband to see the ghost soldiers. She stood by the window as the ghostly gray fog slowly passed by her window. She stood spellbound as the shapes of ghostly horses, cannons and

many soldiers passed by her window. She could barely hear the horses' hoofs as they pulled the wagons and cannons down the street. She could hear the muffled sounds of human voices but could not make out what the ghostly soldiers were saying. After it seemed like she had been standing by the window forever, she was suddenly brought out of her daze by the sound of a bugle in the far distance, followed by complete silence. The fog, the sound and the ghostly figures were gone.

THE BRICK HOUSE SPIRIT

Brick House was built in 1720 in Charles Town. Shortly after the construction was completed, the Jenkins family bought it. Amelia, with no parents of her own, grew up at the Brick House with her aunt and uncle. She had a wonderful childhood living in Charles Town.

Amelia was good friends with an Indian boy named Concha. He shared his adventures with Amelia. Amelia, becoming a tomboy, learned to swim, climb trees and ride horses.

Amelia turned eighteen, and the Jenkins family threw her a stylish birthday party. They invited all of the prominent people of Charles Town. As Amelia prepared for her eighteenth birthday party, she heard her friend calling to her. Since he was not invited to the birthday party, she slipped out to talk to him. They met in the shadows near the

woods. Concha told Amelia that he loved her. He begged her to journey into the woods with him. Amelia refused. She left him standing in the shadows as she returned to her bedroom. As the minutes passed, she forgot about the incident with Concha. As the party progressed, she began to have fun with Paul Grimball.

Amelia was soon engaged to Paul Grimball. Soon after the engagement was announced, plans for the wedding were made.

One night, Amelia was awakened by her friend Concha's birdcall. Not wanting to speak to him, she did not answer.

One day, Amelia decided to go crabbing. As she waded into the water and looked down at her reflection, she was surprised to see Concha's reflection beside hers. As she backed away, she cut her foot on an oyster shell. Concha helped Amelia out of the water and to her house. He professed his love to her again. Amelia told Concha that she was in love with Paul and that she had made plans to marry him. Concha left alone, screaming at Amelia. In the days that followed, Amelia never left the house by herself.

On the night before the wedding, she and Paul took a stroll out into the gardens. They did not notice Concha hiding in the shadows.

On the night of the wedding, the house was filled with the families of the bride and groom and their guests. They eagerly awaited the bride's entrance. Amelia, in her bedroom waiting for the time to go downstairs, was dreaming of her upcoming life with Paul. Suddenly, she

let out a piercing cry as an arrow struck her in the breast. Badly wounded and near death, she staggered down the stairs as Paul was going up. She fell into the arms of her intended on the thirteenth step. As Paul held her, the blood slowly drained from her body, and she breathed her last. The thirteenth step was covered in Amelia's blood. Efforts were made to remove the bloodstain from the thirteenth step, but all efforts failed. No one from that night on stepped on the thirteenth step.

In later years, the house was destroyed by fire, leaving only the brick shell still standing. At the northwest window of what remains of the house, in the late hours of the night, you can see what appears to be a lady dressed in shimmering white clothes looking out. Those who have seen the ghostly white specter say they can hear a loud cry of pain.

THE WHITE OWL

The exact location and time of this story have been lost as the story was handed down.

As the story goes, it seems that a man owned a small amount of land in the post–Civil War era. The family and farm, in need of money to keep them going, had no way to raise it except to sell part of the land.

The man's wife did not want the land sold. As their arguments of the impending sale of the land became more and more intense, the man knew he had to sell the property

to save the family and the farm. As the man prepared to journey into town to sell the property, his wife told him that if he sold the property, when he returned she would not be there. Still intent on selling the land, he hurried into town.

As the hours passed, his wife, beside herself, paced the floor. She suddenly stopped and looked out the front window at the giant live oak tree covered with moss. As she stared at the tree, she knew what had to be done. She had made her husband a promise, and she was going to carry it out. Her death would be on his hands. She got a rope from the old shed out back. She rolled the rain barrel over to the tree. Climbing onto the rain barrel, she tied the rope around a tree limb. In one last fit of anger, she tied the rope around her neck and jumped off the barrel.

When her husband returned home after selling the land, he found his beloved wife hanging from a limb of the old oak tree. As he drew nearer to the tree, he noticed something white on a limb just above his wife's lifeless body. As he reached the tree, he saw that it was a white owl. He tried yelling at the owl in order to scare it off, but the owl refused to moved. He threw rocks at it, but it only moved to another location in the tree. When he stopped, it would move back to its original place on the limb above his wife. Forgetting about the owl, he cut his wife down and took her body into their house. The owl remained on the tree limb. People passing by today say you can still see a white owl in that old oak tree.

STRANGE THINGS FROM THE SKY

What could be behind these strange things that fall from the sky? Could it be strong winds, storms, tornadoes or waterspouts that are sucking up these things and then releasing them in another part of the country? There have been accounts of things falling from clear skies with no rain or wind. Is this a supernatural occurrence, aliens, UFOs, a parallel world or objects from another dimension, or is it just a manifestation of miracles?

Whatever the cause and wherever they come from, things have been falling from the sky for all of recorded history.

On September 4, 1886, a shower of warm stones repeatedly fell from the sky on the offices of the *News and Courier* in Charleston. The first shower was at about 2:30 a.m. Another occurred at about 7:30 a.m., with an encore performance at 1:30 p.m.

Observers reported that the stones fell in a small area around the newspaper office. Many of the stones shattered upon impact with the pavement. Witnesses described the rocks as polished pebbles of flint. Some were reported to be the size of a grape, while others were as large as an egg.

In June 1901, during a heavy rainstorm at Tillers Ferry, South Carolina, hundreds of small perch, trout and catfish fell on this tiny community. After the storm was over, the fish were swimming in the water that had settled between the rows on Charles Raley's farm.

After a rainstorm in Hemingway, South Carolina, in the late 1960s, a young girl attempting to do her daily chore of gathering eggs was surprised to find a chicken yard covered with small fish.

In October 1886 in Aiken, South Carolina, residents witnessed a heavy rainstorm. It rained from early morning until late that night. There was nothing unusual about that type of rainstorm, except that it only rained on two graves in the town cemetery.

In 1877, several small alligators fell on J.L. Smith's farm in South Carolina during a strong downpour. The alligators were unharmed after falling a great distance and crawled away.

On July 2, 1943, during a heavy rainstorm in the Charleston area that lasted for several days, several small alligators fell on Aston Street.

In December 1943, during a heavy rainstorm that lasted several hours, small alligators fell in Aiken County.

In the autumn of 1886 in Aiken County, the skies were clear when out of nowhere a mysterious rainstorm appeared. The rain fell on an area about ten square feet. The cause for this strange rain phenomenon is still unexplained, yet it continues to happen. It has been recorded throughout history.

In October 1886 in Chesterfield County, South Carolina, under a cloudless sky a heavy rainstorm appeared out of nowhere. The heavy rain soaked a small piece of land. This rainstorm could not be dismissed as a freak rainstorm because it lasted fourteen days.

In January 2002 in Charleston, a large chunk of ice fell out of a clear sky. It tore a hole in the roof of a car dealership. One of the cars was damaged when the ice landed on top of it.

SULLIVAN'S ISLAND WAR PIT

There's a little-known revolutionary park on Sullivan's Island. Inside this park is a large, steep hill covered in bamboo trees. This steep hill surrounds a deep pit where the Fort Moultrie soldiers kept the redcoat prisoners during the Revolutionary War. The pit is surrounded by steep granite walls.

If a redcoat prisoner tried to escape, one of the Fort Moultrie watchtower guards would shoot him. Many times, the bullet did not kill the prisoner; instead, he was left in the pit to die an agonizing death. Some would live several days, and some weeks, before death would ease their pain. Death was welcomed by many of the prisoners.

Legend says that you can still hear the shots being fired by the Fort Moultrie soldiers and the agonizing screams of the prisoners as the bullets rip through their bodies.

THE WHISTLING DOCTOR

About two hundred years ago, a young doctor, Dr. Joseph Brown, came to Charleston to set up his medical practice. Dr. Brown was immediately accepted by everyone and very well liked. He quickly made friends throughout the city of Charleston. As his patients and friends grew in numbers, he became even more popular. Dr. Brown lived in a rented room on Church Street.

Whenever he would go walking, he would whistle. Everyone in his neighborhood knew when Dr. Brown would go for a walk down the streets of Charleston because they could hear him whistling his old, familiar tune. The young doctor whistled the same tune every time he went for a walk.

One night, after seeing a play, Dr. Brown engaged in an argument with another patron of the theater about the play. He was challenged to a duel to be held the next day at sunrise. The following morning at sunrise, the two men met at the appointed place and time for their duel. Each man had his second with him. On the day of the duel, things looked a little different. The argument didn't seem as important as it had the night before. Now, neither man was interested in killing the other. As each drew and aimed at his opponent, Dr. Brown aimed at the ground just in front of the other man. Dr. Brown's opponent shot him in the leg.

Several days later, blood poison set in. Dr. Brown grew weaker with the passing of each day. His landlady feared he would not live.

One morning, as his landlady drew nearer to his room to check on the young doctor, she could hear the faint sound of Dr. Brown whistling his familiar tune. Thinking that he was much better, she hurried to his room. She knocked on the door, but no answer came. She slowly pushed the door open and found Dr. Brown lying on his bed, expired.

Many people since then have heard the young doctor whistling in his room. Many local residents have heard Dr.

Brown whistling as they stroll down Church Street. Many visitors have heard Dr. Brown whistling his old, familiar tune as they stroll the streets of Charleston.

•

REEDY CREEK SPRINGS

Even though there are no known ghost stories tied to Reedy Creek Springs, it is still an interesting part of South Carolina's history.

A few miles outside of Bingham, South Carolina, just off Highway 34, there is an old dirt road. Just a few yards back in the woods stands the once-famous Reedy Creek Springs. As time and the elements took their toll, Reedy Creek Springs changed from a thriving vacation spot into nothing more than a small water hole.

The only remnants are the steps believed to belong to the hotel and scattered pieces of the concrete walk that once led to the springs, both in shambles.

Reedy Creek Springs can be traced back as far as the Civil War. In 1878, Mr. Allen developed Reedy Creek Springs on 125 acres of land. When Allen took over the property, there were two small cottages and a small building around the springs. Allen transformed the springs and surrounding area into a summer resort. Twelve cottages were built for vacationers to rent. Shortly after, a twelve-room hotel with a porch in the front and back was added. The hotel was located about 250 feet from the

springs. A fine dining room, a kitchen, storehouses and servants' quarters were constructed. Stables were erected to house employees' and vacationers' horses.

Later on, a pavilion was built. Lightwood ("lightered" as it's known in the South) was used to provide light for the pavilion. Not only did it give off a good light, but it also had a long-lasting flame, which helped keep mosquitoes and other pesky bugs away. The lightwood torches gave the pavilion a romantic look.

Allen's purpose was to develop the springs as a kind of health resort. The water was known for curing many ailments such as liver and kidney problems, loss of appetite and just about anything else you could think of. Allen had the state chemist analyze the water. It was found to have a high mineral content.

In 1895, a railroad was built that came through Bingham. The railroad added to the popularity of the springs and made them more convenient for people to reach.

In 1909, Allen sold the springs to Mr. Bethea and Mr. Gibson. These two businessmen organized a company to bottle Reedy Creek Springs water so it could be shipped for home consumption.

When the automobile became a popular means of travel, people were able to travel to different places, and the Reedy Creek Springs tourist trade began to decline. Finally, the springs were abandoned, and the buildings crumbled. Now, Reedy Creek Springs is just another story out of South Carolina's past.

THE GRAY COURT TUNNEL BODY

Under I-385, near Exit 10 on South Carolina Highway 101, a body was found under a culvert. The victim had been dead for several weeks. Exposure had wreaked havoc on her body. Reports said she had been raped and murdered. Her attacker was never caught.

The area around the culvert was widely known as a lovers' lane–type place frequented by teenagers.

It has been reported that the ghost of the murdered girl will appear to some of the teenagers who go there. She will press her face against the window while pounding her fist on the top of the car. Her face is mangled and missing part of its features. Most of her lower jawbone is missing, and one eye is gone.

She has also been reported on a nearby frontage road.

It is believed that she is trying to warn the girls to leave before the same thing happens to them.

THE STORY OF SANTA CLAUS

There are many legends that surround Saint Nicholas, Kris Kringle, Father Christmas and, as we know him now, Santa Claus. This is one of the most famous legends and includes elements of the Santa Claus known today throughout the United States.

A nobleman and his three daughters had fallen on hard times. He did not want anyone to know of his misfortune. Since their father had no money and could not pay their dowries, the three daughters were destined to not marry.

One night, Saint Nicholas threw a small bag of gold through the open window into the nobleman's shabby house. This was enough to pay the dowry for one of the daughters. The following night, Saint Nicholas threw another small bag of gold through the open window. Now the nobleman had enough for two daughters' dowries, but which two? The following night, as Saint Nicholas appeared at the house, he found the window closed. Unable to throw the small bag of gold through the window, he climbed on top of the house and dropped it down the chimney. The bag of gold fell into one of the girls' stockings that hung by the fireplace to dry. The nobleman now had enough money for a dowry for all three of his daughters.

As people immigrated to America, they brought their own versions of Santa Claus: the Scandinavians brought the gift-giving elves, the Germans brought the decorated tree and the Irish brought the tradition of placing lighted candles in the windows of their homes.

Santa Claus has not always looked like the jolly old elf we know and love today. He is a mixture of many different cultures and beliefs. Because of his sensitivity and extreme generosity, many groups claim Saint Nicholas as their patron saint.

In 1808, an American writer, Washington Irving, created the new version of Santa Claus. This incarnation

flew over the housetops in a wagon drawn by a horse and dropped gifts down the chimney. In 1822, the classic poem by Clement Clarke Moore, "The Night Before Christmas," gave a North Pole version of Santa Claus. In the poem, Santa rode in a sleigh drawn by eight tiny reindeer: Dasher, Dancer, Prancer, Vixen, Comet, Cupid, Donner and Blitzen.

In 1863, Thomas Nast gave Santa Claus a visual image that immediately became widely accepted.

In 1931, artist Haddon Sundblom added the final touches to Santa as we know him today. That year, the modern version of the continuing legend of Santa Claus added elves as toy makers who run Santa's toy factory.

In 1939, an advertising writer for Montgomery Ward introduced Rudolph as the ninth reindeer.

The American version of Santa Claus has Santa living at the North Pole with Mrs. Claus and the toy-making elves. Santa is known as a jolly old man with a white beard who wears a red coat with a white collar, pants trimmed with white fur, a black belt with a big yellow buckle, black boots and a red pointed hat with white fur around the bottom and a white ball at the tip. Santa brings toys to all the good boys and girls on Christmas Eve, December 24.

Santa exhibits the two basic principles of the Christmas holiday spirit: giving to others and helping the less fortunate.

BUDDY

Poston is a small, sparsely populated rural community where everyone knows everyone, located in eastern South Carolina. Nothing ever happens in this small rural community, except during the Christmas holidays. During the Yuletide season, the outdoor lights go up by the thousands. At night during the holiday season, Poston, South Carolina, becomes a tourist attraction, attracting hundreds of people from the neighboring towns and cities.

A Poston resident had a distant relative named Buddy. Buddy suffered from severe arthritis in his hands. He had to walk with his hands held upward toward his chest.

An unnamed young man, about twelve or thirteen years old, who grew up in the Poston community was riding home with his grandfather one night. It was a clear night with a full moon, so visibility was good. The young man noticed an old man walking on the right side of the two-lane road facing the traffic. As they drew nearer, he noticed that the old man looked a lot like his distant relative Buddy. Buddy had died several weeks earlier and had been laid to rest in the community cemetery.

The old man walking the road had the same affliction with his hands as Buddy did. He held both hands up toward his chest. As they passed, he threw up one of his hands and waved at them as best he could. The youngster didn't say anything to his grandfather about the old man walking on the road; he just dismissed him as someone who

resembled Buddy. He should have known there couldn't be another man in Poston who looked that much like Buddy. He looked just as human as his grandfather did sitting there beside him. He wasn't transparent or white or anything that would make the young man think he was a ghost.

Many years later, while serving his time in the military, the young man was home on leave visiting some family in Poston. They were sitting around in the living room talking when his sister mentioned a time when, as a child, she was riding home with her grandfather one night. She said it was a clear night with a full moon. They were on the same stretch of the road the young man had been on with his grandfather when she saw a man walking toward them. As they got closer to the man, she realized it was Buddy. It wasn't until that night that the young man realized he had seen the ghost of his distant relative Buddy. No other sightings of Buddy have been reported.

JOHNSONVILLE LIGHTS

On May 5, 2009, at 8:50 p.m., I was making my rounds outside a warehouse where I work as a security officer. The sky was overcast with low clouds, and the moon and stars were not visible. I was walking west when I noticed a bright gold, glowing round object hovering motionless. It was much lower than planes fly. At first, I thought it was a flare, but there was no movement, sparks, smoke, sound or vapor

trail. It sat there motionless for a few seconds, and then a second one appeared in front of it, the same color and size. They were both motionless. A few seconds later, a third one appeared in front of them; all three were motionless. They sat for a few seconds and then started to slowly move toward the east, still making no sound, spark, smoke or vapor trail. At once, all three vanished. There were no visible signs that anything had been there. The lights were visible for maybe a minute. I could not see any planes in the area. These lights were observed on Egg Farm Road.

Johnsonville UFO

Johnsonville, South Carolina, is a quiet, peaceful little town. Nothing exciting ever happens here. This was not the case, however, for Jack Smith. On December 3, 2009, Smith, a retired supervisor from a telephone company who was working as a security guard, was making his rounds outside a warehouse. Instead of walking next to the building, he was walking down Egg Farm Road, which is about thirty feet from the building. As he looked up, looking for a shooting star, he noticed that the sky was clear, with a few broken clouds scattered about. About 5:20 a.m., he noticed a glowing white, cigar-shaped object. It was in the northeast sky at about the eleven o'clock position several hundred feet up.

The object was very large and had no blinking lights. No sound could be heard coming from it. He could not

tell if it was moving or if the clouds were moving. It could still be seen as it passed behind the clouds. As the clouds covered it, the cigar-shaped object turned pink. This lasted for about fifteen seconds. As the clouds completely covered the object, it disappeared from view. Smith waited for a few minutes to see if the object would reappear. It never did.

GOVERNOR GIST'S GHOST

Rose Hill State Park has its share of ghostly legends and myths. There are mysterious lights that sometimes appear in the woods shortly after dawn. Hunters and visitors who have seen these lights say they resemble a man on a horse carrying a lantern. Many believe that the mysterious lights are the ghost of Governor Gist and his horse making their morning rounds. Each morning, Governor Gist would saddle up his favorite horse and ride around his estate. Since this is his former home, many believe he is still checking on his former estate.

Another version of the ghostly lights in Rose Hill State Park concerns the Gist family before the Civil War. One of Governor Gist's daughters had befriended a slave girl who worked on the Gist estate. One day, Governor Gist's daughter and the slave girl were picking berries near Sardis Road when a horse-drawn carriage came along. The horses were spooked as the carriage neared the two girls, and the driver was unable to control them. Governor Gist's daughter

saw the out-of-control horses coming toward them in time to jump into the nearby woods to safety. Her cry to the slave girl, however, was not heard in time to save her. The slave girl, unable to get out of the way, was trampled by the horses. By the time the young Gist girl could run home and get help, the slave girl had died.

Many people traveling along this stretch of road have reported seeing a young white girl jump into the woods and a young black girl vanish.

THE DEVIL'S STOMPING GROUNDS

Did the Prince of Darkness once live in South Carolina? The devil may have taken up residence here in the Palmetto State.

In Lancaster County, near Highway 521, one might find what is considered to be the oldest crop circle in America. This, however, is no regular crop circle, and it was not made by aliens or pranksters. This area, similar to a crop circle, measures forty feet in diameter. It is circular, and no plant life will grow within the circle. No living animals, not even an ant or an earthworm, can be found inside the circle. The story goes that no animal will cross the circle. Tests have been done on the soil, and it was found to be sterile.

There are several legends that surround this mysterious circle. One such story claims that if you put an object in the circle at night, by morning it will be moved to the outside of the circle.

A consistent feature of the Devil's Stomping Grounds is an overwhelming feeling of dread, despair, nausea and impending doom in anyone who stands within the circle and clears their mind.

One report says that a scout troop set up a tent in the center of the circle only to find that it had been mysteriously moved to the outside of the circle the next morning. The tent was exactly as it had been set up; even the stakes were stuck into the ground.

One of the local stories is that this area once served as an execution site for the Waxaw and Catawba Indians. It is said that the devil himself frequents this spot to collect the condemned souls of the executed people.

Another story is that the devil comes back at night and walks around the circle to think up evil deeds to do to

unsuspecting mankind. The devil moves the objects out of the circle so they won't be in his way while he walks and makes evil plans.

TRIANGLE OBJECT OVER MYRTLE BEACH

On September 10, 2007, a family was vacationing at Myrtle Beach, South Carolina. They had planned this vacation for over a year, and Myrtle Beach was the perfect place for a much-needed rest. One member of this family had an experience that would make this vacation one to remember. They were staying on the twelfth floor, oceanfront, of one of the many high-rises that dot the coastline.

A female family member was sitting on the balcony enjoying the night and the cool ocean breeze and watching the ocean. This was a welcome feeling after a hot day spent along the Grand Strand. As she looked up at the sky, she noticed three lights, two white and one red, in the southeastern sky. They seemed to be motionless and made no sound. She found a pair of binoculars and tried to get a better view of the lights. With the aid of the binoculars, she was able to make out the faint outline of the object. It was large and triangle-shaped. As she watched the object hovering above the ocean, she noticed that at the far end there was a group of white lights with a green light in the middle.

She watched the triangle-shaped object for about an hour and half. It remained motionless at an estimated two

hundred feet above the ocean. The white lights would go out while the other lights would remain on.

After about an hour and half, the craft began to silently move toward land in the direction of the hotel. Still a good distance over the water, it stopped and remained motionless. After about fifteen minutes, it turned back toward the open ocean and silently moved away.

NORTH MYRTLE BEACH LIGHTS

Three college friends were taking a much-needed vacation in North Myrtle Beach. One night, the friends were taking their evening constitutional along the edge of the water. One of the friends glanced out over the ocean. He noticed orange and yellow glowing spheres off the coast. In a matter of seconds, the other two noticed the lights. As they watched the lights for several minutes, the lights began to fade out, and shortly they were gone. A few minutes later, they reappeared in another location. The friends watched for a few minutes, and the lights faded out again. They did not reappear.

MYRTLE BEACH TRIANGLE LIGHTS

While surf fishing in Myrtle Beach, a vacationer noticed an orange light slowly begin to appear. He estimated it to be about two to three miles out over the ocean at about

a twenty- to twenty-five-degree angle. The moon hadn't come up yet, so the ocean was dark. The light began to get brighter, and then a second light appeared, followed by a third. The lights created a triangle. They remained there less than a minute, and then the first light started fading out, followed by the second one and then the third. This happened three more times at different locations over a period of about twenty minutes.

LOONEY'S BRIDGE

Many ghost stories are handed down without documentation to back up the legend and dates; therefore, many very important historical facts have been lost forever. Stories are changed to accommodate the teller and the situation. Haunted bridges are scattered throughout rural America. Bridges are modern people's method of crossing small streams, creeks, rivers and much larger bodies of water. Millions of people cross bridges every day on uneventful journeys. However, a chosen few of these people will never make it across. They meet with untimely deaths at their own hands or at the hands of someone else. Some bridges have been used as instruments of suicide for people whose lives have lost their meaning. The Grim Reaper or Angel of Death is standing there waiting.

A select few never leave the bridge where they died.

The area around Johnsonville, South Carolina, is dotted with small bridges that cross creeks and river branches.

Perhaps the best-known bridge is Looney's Bridge on Gaster Road in the Possum Fork community. There are several legends that surround this bridge.

In the 1700s and 1800s, transportation was by mule and wagon. The weekly trips into town were to pick up the much-needed supplies that weren't grown on the farm or traded with the neighbors.

One of the stories dates back to the 1700s. The exact date and name of the girl has been lost. A young woman, maybe in her early twenties, was preparing for a trip to the neighboring farm. It had been an uneventful day like always on the farm. One of the farmhands was preparing her mule and buggy for her trip. Her family had just killed several hogs, and she was going to take some fresh meat to their neighbors on the next farm. As she climbed into the buggy, the farmhand handed her the reins. She waved to her family and rode off, not knowing that this would be her final ride.

As the buggy rumbled down the old dirt road, dust billowing up behind it, her thoughts were on her gentleman friend, whom she would see the next day. She was not paying too much attention to the road as the buggy neared the old wooden bridge. A heavy rain the night before had washed out a trench between the road and the bridge. As her wheel hit the trench, she was thrown from the buggy. One foot was caught inside the buggy. As she hung helplessly outside the buggy, her head beat against the buggy wheel until she was dead.

Her foot came loose, and she rolled into the ditch on the side of the road.

The neighbors weren't expecting her, so she wasn't missed for many hours. As the evening sun was sinking low and the pastel colors dotted the sky, her family began to worry about her. As darkness slowly crept across the land, they set out to hunt for her. The family readied their kerosene lanterns as the farmhands prepared the mule and wagon. Her father and the farmhands walked along the road as her mother drove the mule and wagon. They found no sign of her or her mule and buggy. They reached the neighboring farm and were told that she never arrived.

The neighboring family got their lanterns and joined the search. Her family searched the road back to their farm in hopes that she may have returned. The neighbor family continued the search down the other end of the road. As the families met up later that night, neither had found any sign of the missing girl or her mule and buggy.

The following morning, a farmer crossing the bridge heard a faint call for help. It sounded like a young girl. As he dismounted his mule and followed the sound of the voice, he discovered the battered young girl lying in the ditch. Recognizing her and realizing that she was dead, he wrapped her in his coat and hurried to tell her family.

The family and the farmer returned to the bridge with the wagon. They took the girl's lifeless body back to the farm. The following day, a funeral was held for her, and

she was laid to rest. At least that's what they thought. Many people passing over the bridge have reported hearing a young girl calling for help.

Looney's Bridge hasn't changed much. It was once an old wooden bridge and is now a concrete one that spans the creek. It is out in the middle of nowhere in the Possum Fork community of Johnsonville, South Carolina, and is considered to be haunted. Another story goes back to the late 1800s, when all of this area was farmland.

Late one evening, a young lady was on her way home from a weekly visit to the general store. As she was crossing the bridge, her mule bolted and threw the girl from the wagon, breaking her neck as she landed on the bridge. The well-trained mule continued on home without the girl. When the mule and wagon arrived home, the father was in the yard doing some last-minute chores. When the girl was discovered missing, the family followed the road and found the lifeless body of the girl lying on the bridge. The family took the young girl home. The story goes that if you go to the bridge late in the evening or at night and call "Looney" several times, you will see a young girl standing on the bridge.

Another version says that when the girl landed, her head was under the wagon. The wagon wheel ran over her, cutting off her head. The girl's head was never found, although many searched for it. Sometimes when the moon is bright, you can see a young girl walking on the bridge looking for her head. Another legend says that if you park

your car on the bridge and turn it off, it won't start again until you push it from the bridge.

In the old days, a driver would make the mule trot over the bridge so as not to disturb the dead girl.

A VISIT TO THE DOCTOR

A man walking home from seeing Dr. Johnson was approaching a bridge. As he neared the bridge, he heard a voice. Fearing that it might be someone wanting to rob him, he walked around the bridge through the creek in hopes that the person would think he was an animal and leave him alone. After he crossed to the other side, he no longer heard the voice.

THE DOG FENNEL

Three young boys were making their way home one night. The moon was full, and a light breeze was blowing. It was cold, and the frost had already fallen. As they approached the bridge, they saw something on the other side bowing down. Each time they took a step closer, it would bow down. After several minutes of waiting, they decided to run across the bridge. Arriving on the other side, they found that it was only a dog fennel covered with frost moving in the wind. (A dog fennel is

a short-lived summer perennial that grows wild in fields and on the side of ditches. The leaves on a dog fennel are divided into threadlike segments, giving the plant a fernlike appearance.)

SOUTH CAROLINA'S MERMAID

In 1867, after the South lost the Civil War, it was ripe for the picking. Every carpetbagger, crook and anyone else looking to make a quick dollar off the unfortunates headed to the South. One particular man stands out in the minds of the people of Charleston. Dr. Cavanaugh, a strange, well-dressed, slim Yankee, arrived in Charleston to open an apothecary. Dr. Cavanaugh was a purveyor of prescriptions, potions, pills and other magic cures. He had a remedy for anything that ailed you, and if you simply thought something was wrong, he had a remedy for that, too. Dr. Cavanaugh, looking to make some easy money, chose Charleston because of the shipping port and large population.

Dr. Cavanaugh set up his apothecary near the docks in hopes of attracting some business from the many people passing through the port. However, his best-laid plans failed. The people of Charleston had their own apothecary, and the people passing through weren't interested in his high-priced wares.

After a month of little to no business, most people would have packed up and moved on, but not Dr. Cavanaugh.

He was a cunning businessman who had other plans. Dr. Cavanaugh contacted every sailor he could find. After several days of this, he went into town and placed a large order for sheet glass. Just before the glass was to arrive, he hired some men to move the apothecary to the second floor and a crew to remove everything from the bottom floor. Many of the town folks thought Dr. Cavanaugh was out of his mind. He wasn't getting any business on the first floor; surely he didn't think moving the apothecary to the second floor would increase his business.

When the glass arrived, a crew of glassworkers accompanied it. The windows were covered with black cloth, and the glassworkers went to work. The sailors were sneaking in carrying all sizes of boxes and jars covered with cloth so no one could see what was inside. After several weeks of this, the townspeople's curiosity took control. They started walking by the building. At times, they would see Dr. Cavanaugh standing outside the door not saying a word.

One day, a sign appeared in the window: "Ten Days until the Hall of Wonders." Each day, the date on the sign would change, counting down the days until opening day.

On opening day, most of the people of Charleston turned out to see what the Hall of Wonders was. As the door slowly opened, the mysterious figure of Dr. Cavanaugh emerged to greet the people:

> *Greeting ladies and gentlemen and welcome to the Hall of Wonders. Today, you will see things that you've*

*never seen before and probably will never see again.
For a measly penny, you can journey through the Hall
of Wonders.*

The room was filled to capacity in minutes. Many people
had to wait outside for their turn.

The entire first floor had been turned into a giant
room filled with glass tanks. In the center of the room
hung a magic lantern that gave the effect of being under
water. As the lights were brought up, the people stood
in awe. Thousands of colorful fish were swimming
in lighted tanks. After the customers had been given
ample of time to enjoy the strange and colorful fish, Dr.
Cavanaugh ushered them to the far end of the room. He
slowly pulled back the drapes that were covering a large
tank. This was the largest tank in the building and was
filled with murky emerald water. A sign in front of the
tank read: "Mermaid."

The crowd gathered around and stared into the
emerald water trying to get a glimpse of the fabled
mermaid. After several uneventful minutes of staring into
the murky water, something moved. The spectators got a
glimpse of what looked like large silver fish tail and shiny
yellow hair. Dr. Cavanaugh announced that this was the
end of their tour, and they were sent out to make room
for the next group. For the next few weeks, the large room
continued to stay crowded. No one ever got a good look
at the mermaid in the tank.

On July 3, 1867, a black squall moved into Charleston. The squall was followed by heavy rain and thunderstorms. For nearly a month, Charleston was pounded with heavy rain, thunder and lightning. This ended Dr. Cavanaugh's business. As the rain continued

its downpour, the people of Charleston became a little worried. Not even the oldest people living in Charleston could remember a storm like this.

Many people in the city were superstitious and began to believe that someone or something was causing this rain. It couldn't be the townsfolk, and the only newcomer was Dr. Cavanaugh. People started talking about him and pointing fingers. A local conjure woman started having visions about Dr. Cavanaugh. No one had ever paid much attention to the old conjure woman until now. People were beginning to listen to her ranting and raving. "It's the mermaid that's causing the problems," she said. The conjure woman was spreading rumors that a mermaid was a girl who washed out to sea and didn't drown but couldn't get back to land. She was turned into a mermaid—half fish, half human—so she could live in the sea. Once they turned into mermaids, they could not return to land. If a mermaid washed up on land, the only way she could get back out to sea was to call for rain to wash her back out.

After much of this talk around town, many people headed over to Dr. Cavanaugh's apothecary. Dr. Cavanaugh met them at the door. "Release the mermaid!" shouted the crowd.

Dr. Cavanaugh responded, "It's only a trick."

But the crowd wasn't listening. They stormed the building and started smashing the tank. In a split second, something washed out of the tank and into the street and disappeared. The people picked themselves up and

started looking for Dr. Cavanaugh, but he, too, was gone. Shortly after whatever was in the tank washed away, the rain stopped and the sun came out.

THE GREAT PACOLET FLOOD OF 1903

The Pacolet flood was responsible for the greatest loss of life from river flooding in this century. The flood occurred along the Pacolet River near the town of Pacolet, South Carolina. During the early morning hours of June 6, 1903, when everyone was asleep, a strong convergence, plus an upslope flow of warm air associated with a low pressure system, moved into the area causing a heavy downpour. The rain came so fast that the river could not hold all the water. According to the National Weather Service, the water rose so fast that the land near the river was covered with forty feet of water within an hour. Sixty people along the river lost their lives.

Train traffic was disrupted in the area. Houses, churches, industrial plants and corn and flour mills were completely destroyed. The communities of Pacolet and Clifton were the hardest hit. Some flooding damage reached areas along the streams in northwest South Carolina. The flood caused about $5 million in damage.

THE 1924 HORRELL HILL TORNADO

On April 30, 1924, an estimated F4 tornado with winds estimated at 207 to 260 miles per hour destroyed a 135-mile path across South Carolina. The Horrell Hill tornado was the longest tornado to touch down in South Carolina's history. The tornado spawned in Aiken County from severe thunderstorms and spread its death and destruction into Darlington County. When the tornado finally died out, over sixty-seven people had perished. Almost half the deaths were in Richland County, and half of those were in the Horrell Hill community.

THE 1908 FLOOD

The August 26–30, 1908 downpour brought the most extensive flood in South Carolina's history. A low pressure system formed in the Gulf of Mexico and moved northeast across South Carolina, causing unprecedented statewide flooding. The major rivers rose from nine to twenty-two feet above flood stage, causing extensive damage to homes and crops along the rivers.

DROUGHT OF 1925

The year 1925 brought the most widespread and disastrous drought in South Carolina's history. From February to the

second week in November, the rainfall deficit reached 18.23 inches. During the peak growing season, the rainfall deficit was 12.41 inches. Rivers dried up, crops failed, livestock died and deep wells went dry. Losses were about $5 million.

THE 1928 FLOOD

The hurricane of September 21–24, 1928, brought statewide flooding. The average rainfall was ten to twelve inches, causing bridges, railroads and roads to be destroyed or become impassable.

THE 1954 DROUGHT

The year 1954 brought a disastrous drought, especially during the summer months. The hottest months suffered the worst. Small streams dried up and crops failed. Statewide annual rainfall was 32.96 inches, which remains the record for the driest year in South Carolina history.

THE 1984 TORNADO OUTBREAK

On March 28, 1984, one of the most intense low pressure systems on South Carolina record moved across the

Palmetto State. This unusual low pressure center spawned eleven tornadoes and damaging thunderstorms.

The first tornado hit Honea Path and was followed by ten more tornadoes along a line from Anderson and Newberry Counties traveling east to northeast through Marlboro County.

Fifteen people lost their lives as a result of this tornado outbreak. Six other deaths were associated with this severe weather outbreak. Damage estimates exceeded $100 million.

HURRICANE HAZEL

In 1954, South Carolina was facing recovery from a record drought in the spring and summer months. Little did the people know that the unsuspecting South Carolina was in for another seriously devastating blow. Mother Nature was about to unleash her fury again on the Palmetto State; this time, with a hurricane of unprecedented force. Hurricane Hazel was about to attack the already weakened state.

Late on October 14, just before it reached the Carolinas, a hurricane plane reported the winds at 140 miles per hour, making the storm a category four hurricane. Hurricane Hazel was traveling at about 30 miles per hour. Landfall was just hours away.

Hazel made landfall on October 15 at the North Carolina–South Carolina border as a category four

hurricane. On the morning of October 15, Hazel hit Myrtle Beach, South Carolina, with winds at 106 miles per hour. The Grand Strand was devastated by the powerful winds.

The incredible amount of damage caused by Hurricane Hazel was exacerbated by the time Hazel struck. Hazel struck land during the October full moon, the highest lunar tide of the year. Despite the devastation caused by Hurricane Hazel, South Carolina suffered only one death connected to the hurricane.

Hurricane damage from Pawley's Island to Cherry Grove was about $24 million; 273 houses were destroyed at Myrtle Beach, representing about 80 percent of the waterfront property.

Hurricane Hazel was the deadliest and most costly hurricane of the 1954 Atlantic hurricane season. As a result of the damage, Hurricane Hazel's name was retired. Hurricane Hazel caused about $27 million in damage in South Carolina.

BLIZZARD OF 1973

February 8–11, 1973, were four days that will go down in weather history in South Carolina. Ask anyone who was living in South Carolina on those days, and they'll tell you about the worst winter blizzard in the history of South Carolina. The 1973 snowstorm that crossed

the southeastern states brought record-breaking snow. On February 9, South Carolina residents witnessed the biggest winter event to ever happen in the Palmetto State. Snow fell for twenty-four hours beginning in the late afternoon, and many areas received more than a foot of snow. A low pressure system off the coast combined with cold air fueled a massive winter blizzard. This blizzard was called a superstorm by weather forecasters.

More than thirty thousand tourists were stranded on the state's highways; many had to be rescued by helicopter. In some areas, snowdrifts were up to eight feet.

The snowstorm, accompanied by strong wind and severe cold, caused about two hundred buildings to collapse. Thousands of awnings and carports were destroyed. Trees and power lines were downed. Many spent weeks in the bitter cold without power. Eight deaths in the state resulted from exposure. It took South Carolina residents months to recover from the blizzard of '73.

The following are some snowfall totals from across the state: Rimini, twenty-four inches; Bamberg, twenty-two inches; Manning, twenty-one inches; Lake City, seventeen and a half inches; Florence, seventeen inches; Columbia, sixteen inches; Summerville, fifteen inches; McColl, fifteen inches; Aiken, fifteen inches; Kingstree, thirteen inches; Conway, twelve inches; Murrells Inlet, nine and a half inches; Charleston, just over seven inches; Beaufort, six inches; Rock Hill, four inches; and Hilton Head, two inches.

Hurricane Hugo

On September 21, 1989, Hurricane Hugo was a category four hurricane with maximum sustained winds at 140 miles per hour. Hugo made landfall at 11:00 p.m. on Isle of Palms near Charleston. While the winds and rain battered the coast, high tides were devastating the coastline, washing away much of the beach sand.

Thirteen deaths were directly related to Hugo, twenty-two deaths were indirectly related and several hundred injuries were reported across the state.

The damages in South Carolina were estimated to exceed $7 billion, including $2 billion in crop damage.

The Gray Man of 1989

The gray man made an appearance in 1989 before Hurricane Hugo hit. A retired couple out for a leisurely stroll down the beach on Pawleys Island noticed a young man in the distance. They noticed that he was shrouded in a gray mist. When they reached the point where they should have met, he vanished.

Bewildered, they looked around, but there was no one else on the beach. Where did this person go? They immediately returned home.

As Hurricane Hugo bore down on Pawleys Island, evacuation became necessary. As the people returned

to the island in the aftermath of Hurricane Hugo, they found tremendous damage to their homes. When the couple who had encountered the shadowy figure on the beach returned, they found their house completely intact. The only damage to their property was the loss of their beach walk.

THE SHOOTING STAR GHOST

Georgetown, South Carolina, is probably the most haunted area in South Carolina, maybe even in America. Houses, museums, restaurants and plantations—if they're around Georgetown, they probably have a resident ghost. Many unusual ghost stories come from the Georgetown area, but this one is a little different.

This ghost story received a lot of attention during the years following the Civil War. In 1900, a Charleston newspaper ran a story on the ghost. The story reported that the ghost appeared as an old Negro man, well dressed and well groomed in the fashion of the antebellum days.

He always appeared in view and then, within seconds, he would be gone. Many people over the years have reported seeing this ghost. One person reported that he sprang up from the ground and then, just as fast, disappeared.

Many versions of this story have been told, but the most widely accepted is that of an old Negro slave who was murdered where the ghost frequently appears.

The Charleston newspaper named him the "Shooting Star Ghost."

SKY SERPENT

As reported by the *New York Times* on May 30, 1888, three people reported seeing a flying snake or serpent in the sky over Darlington County, South Carolina.

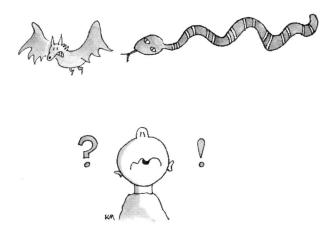

On Sunday evening, just as the sun was sinking low and the sky was covered in pastel colors, Mrs. Davis and her two younger sisters were startled by the sudden appearance of a huge flying serpent slowly gliding through the air above them. They were out for a leisurely stroll through the woods when the giant flying serpent appeared.

The serpent was about fifteen feet long and about fifty feet in the air above them. It was gliding through the air at about the speed of a hawk. Its movements resembled those of a snake but with no visible means of propulsion.

The flying snake was also seen in other parts of Darlington County earlier that afternoon. Some witnesses described it as emitting a hissing sound. All of the witnesses described it as a snakelike serpent with no wings.

Many local people, believing that the Day of Judgment was upon them, feared that God had unleashed a terrible monster. They began holding religious services in their churches. Many declared that it was the devil himself returned to claim his own.

HEMINGWAY AND JOHNSONVILLE

Hemingway and Johnsonville, South Carolina, are just your normal small towns where nothing ever happens. That is, until the sun goes down and darkness creeps in. Are there hidden secrets lurking under the cloak of darkness in these small towns just waiting for some unsuspecting visitor? Hemingway has three traffic lights; Johnsonville has two. Fewer than one thousand people live in the city of Johnsonville and the town of Hemingway. The information I found while doing research for this book leads me to believe that there are more haunted houses, ghosts and headless specters in these two towns than there are living people.

I have lived in the area since 1954, and I have never seen or heard any of these ghosts. No one I've talked with, including the local constabulary, has heard of these ghostly tales. I am including a few of them in this book because,

like all the other stories, I can't prove they are not true. None of these stories gives a location, name or date. Where were the police or other witnesses when all these ghostly figures were roaming our small towns?

Johnsonville

An army uniform without a body has been seen walking around town at night or watching television in a house. There is no record of what war it was in.

The ghost of a male security guard who was shot in the head had been seen coming out of a manhole on a back street in the early morning. Maybe he's reporting to work.

The ghost of a lovely young lady dressed in the uniform of a maid has been spotted floating in the air around Johnsonville. No business or family in Johnsonville employs maids.

The ghost of an elderly white man with a white beard is reported to occasionally be seen walking on back streets at night, looking into people's windows while they sleep.

The ghost of a lovely young bride still wearing her wedding dress has been seen walking the halls of one of the schools located near Johnsonville. The gown is covered with blood. She walks the halls late at night. Maybe she's looking for her old sweetheart.

Hemingway

The ghost of a Confederate soldier, still in full uniform with his weapon, has been seen wandering around a house on the outskirts of Hemingway.

The ghost of a homeless person has been reported in several abandoned buildings in the town of Hemingway.

The ghost of a local farmer wearing overalls and a straw hat has been seen mailing a letter at a local post office. It looks like the farmer just came from working in the field.

The ghost of a teenage girl wearing a bloody prom dress has been seen on prom night at a pay phone making a call. Is she calling for help?

The ghost of a beautiful young bride still dressed in her wedding gown with the veil covering her face has been seen walking along a remote highway just outside the city limits of Hemingway. Her wedding gown is splattered with blood. Is this the result of a wedding day gone bad?

MOUNT PLEASANT SONIC BOOM

On December 31, 2008, many people in the Mount Pleasant, South Carolina area reported hearing mysterious sonic booms. On Tuesday, these booms were heard as far as Georgetown. Residents reported that it sounded like a plane breaking the sound barrier, but no planes were observed.

Calls were coming in from around the area to local law enforcement, radio, television stations and newspapers.

An earthquake was ruled out, but the National Weather Service reported it may have been a phenomenon known as Seneca guns, loud booms that happen in late fall and early winter.

THE DEVIL BIRD

Is South Carolina home to a moth man or devil bird? A few residents in South Carolina believe so. No exact location was given for this story, but it specifies South Carolina.

The creature is described as a giant black-winged figure that flies through the air. Its movements in the air are similar to a hawk. Witnesses to this giant winged creature report that it comes up out of the ground, flies into the nearby trees and vanishes.

According to the legend, anyone seeing this black-winged creature will suffer the loss of a family member within a few days after the creature has been sighted.

BURIED TREASURE

Treasure hunting has been a recreational pastime and obsession for some people in the coastal states. With tales of buried pirate treasure, buried Confederate treasure and many other hidden items of value, treasure hunting continues to grow. Everyone is looking to dig up his fortune in treasure. Any day, you can see treasure hunters walking in parks and along beaches, armed with everything from $19.95 metal detectors to the most sophisticated equipment they can afford.

South Carolina is rich in pirate history and Civil War history. Many treasure hunters come to the state looking for that elusive treasure or other valuable objects. A few relics are unearthed from time to time, but no big discoveries. When General Sherman's army was passing through Kershaw County in South Carolina during the Civil War, the officers of the Camden Bank, fearing

that the army would take over the bank and steal the depositors' valuables and money, collected the bank's assets, took them to a location near Hanging Rock Creek in Kershaw County and buried them.

The men were captured and forced to give up the location of the buried treasure to Sherman's army. A soldier from Sherman's army was appointed to rebury the treasure in another location.

One Friday night, Mr. Rhodes, a relative of the soldier who buried the treasure, and a friend, Mr. Swaggart, unearthed the treasure of gold, silver, cash and other prizes, valued at about $163,000, and disappeared. They possibly went back to their homes up north, but neither has been seen or heard from since.

LYNCHED

No exact date is given, but it was sometime around January 7, 1897, that a lynching occurred. It happened in Stilton, a small village on the South Carolina and Georgia Railroad, five miles below Orangeburg, South Carolina. Stilton was a typical southern community and home to one of the most mysterious lynchings in South Carolina history.

The people of this peaceful little community awoke one morning to discover the body of Lawrence Brown hanging from the danger signal where the old stage road crosses the railroad. Lawrence was one of the most

prominent Negroes in the community and was well liked. The area was soon filled with people awaiting answers. There were no answers, no witnesses and no suspects. The only evidence was a note pinned to his back:

> *Notice to all whom it may concern. Judge Lynches court was in session tonight for the protection of our property and by the help of God he will convict and execute any man, woman or child that burns or destroys our property. We will protect our homes and property and our neighbors shall not suffer loss from fire bugs. Let this be a warning to others.*

Brown was suspected of burning R.E. Wannamaker's barn, but a trial was held and he was found not guilty. One theory is that the guilty party lynched Brown to throw suspicion from himself.

GRANITEVILLE TRAIN DISASTER

The Graniteville, South Carolina train disaster that occurred on January 6, 2005, will go down in American railroad history as one of the worst train wrecks ever. At 2:40 a.m., two trains owned by Norfolk Southern wrecked near the Avondale Mills plant.

The Norfolk Southern No. P22 was parked on a siding near the plant. Norfolk Southern train No. 192 was traveling

on its scheduled route and had no idea that up ahead disaster was waiting. No. 192 was transporting chlorine gas, sodium hydroxide and cresol, all deadly chemicals. Due to an improperly lined railroad switch, 192 was diverted onto the siding where P22 was parked. With no notice, the conductor was unaware that anything was wrong. When he realized there was a problem, he was unable to stop 192 and collided with P22.

The collision was so great that it derailed both engines, sixteen of 192's forty-two cars and one of P22's cars. One of 192's tank cars, loaded with chlorine, ruptured and released about ninety tons of chlorine gas into the environment.

Eight people died at the time of the accident. One person died later due to the inhalation of chlorine. Approximately 250 people were treated for chlorine exposure, and 5,400 residents within one mile of the accident were forced to relocate for about two weeks while the area was being cleaned up and decontaminated.

Summerville UFO

On July 6, 2003, at 8:32 p.m., a strange object was spotted in the Summerville, South Carolina sky. A bright object appeared in the sky in the southwest and was visible for about three minutes. The object was seen coming in from the ocean.

The object appeared to be mushroom-shaped and very bright against the dark sky, with something in the

middle. It seemed to change colors on the inside, from pink to green to blue. The outside appeared to be shining. As it moved downward, its movements were similar to how a jellyfish swims. As it descended, the top appeared to move in and out. It came to a complete stop, and then after a few seconds it began to float back up. It stopped, moved to the right and then stopped again. The object slowly moved back up. Its movements were very smooth. The object did this several times, and then with a quick burst of speed it ascended and then remained stationary for a few seconds. After that, it vanished.

EDISTO ISLAND UFO

On March 27, 1989, shortly after sunset, a storm was approaching the island from out at sea. A family vacationing at their summer home on Edisto Island was sitting on their front porch when one of them noticed a bright round object in the sky. The other members of the family were alerted to the object. It was very cloudy from the approaching storm, so the moon and stars weren't visible. The object appeared to be about two or three hundred feet across and was moving very slowly. The object appeared to be coming out of the woods; it had no lights and made no noise. It appeared to be bright gold. As the family watched it intently, they lost sight of it beyond the trees.

About the Author

Sherman Carmichael, hailing from Johnsonville, South Carolina, is now in law enforcement. He has published newspaper articles on haunted locations for various papers around the state. Carmichael has been interested in ghosts, UFOs, haunted houses and other mysterious things from an early age. He began subscribing to *Fate* magazine at age sixteen or seventeen. At eighteen, he began investigating haunted locations in South Carolina. Over the years, Carmichael has seen and heard many things that cannot be explained. In 2007, he went to work as a researcher for an independent film production company interested in doing a TV series on South Carolina ghost stories. The production company never finished the series due to an illness suffered by the executive producer. In 2008, Carmichael opened his own production company and in 2010 started developing his own series.

Visit us at
www.historypress.net